THE BEST OF
Oil Painting

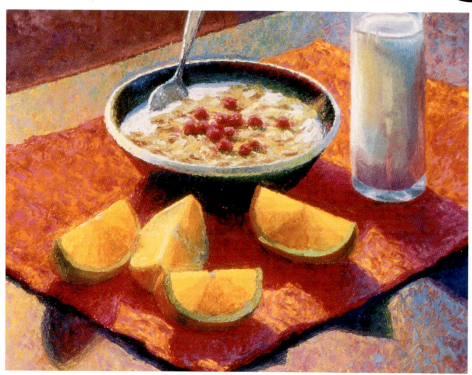

First published in the United States of America by:
Quarry Books, an imprint of
Rockport Publishers, Inc.
146 Granite Street
Rockport, Massachusetts 01966-1299
Telephone: (508) 546-9590
Fax: (508) 546-7141

Distributed to the book trade and art trade in the United States by:
North Light, an imprint of
F & W Publications
1507 Dana Avenue
Cincinnati, Ohio 45207
Telephone: (513) 531-2222

Other Distribution by:
Rockport Publishers
Rockport, Massachusetts 01966-1299

ISBN 1-56496-267-9

10 9 8 7 6 5 4 3 2 1

Art Director: **Lynne Havighurst**
Designer: **Sara Day Graphic Design**
Cover Images: Front cover, left to right: pp. 92, 68, 130
background: p. 33
Back cover, left to right: pp. 84, 135, 95

Printed in Singapore by Welpac

THE BEST OF
Oil Painting

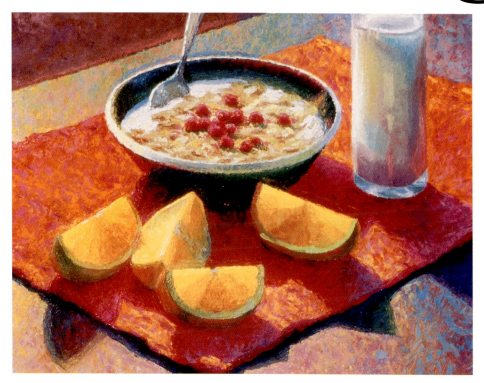

JURIED BY TOM NICHOLAS AND JOHN C. TERELAK

ROCKPORT PUBLISHERS, INC. • ROCKPORT, MASSACHUSETTS

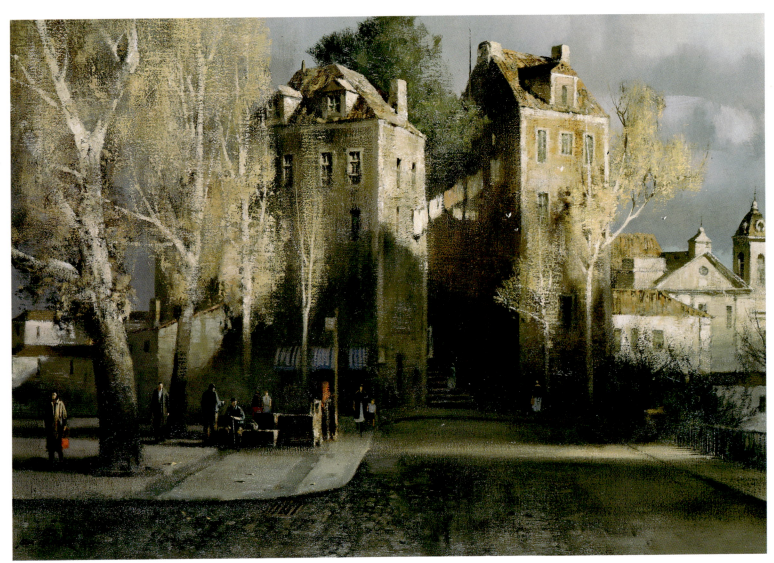

From the collection of Mr. and Mrs. C. Marshall, Naples, Florida

Introduction

I wish to thank Rockport Publishers for asking me, and my colleague John Terelak, to select paintings for this fine volume. Together, we chose works from all regions of the United States. Judging this contest was very difficult; many fine works, unfortunately, were omitted because they fell into categories in which we had excessive submissions.

I would like to make a brief comment concerning our working philosophy. Both John and I devote a good deal of time painting on location, balancing this with studio work. This allows for a direct *en pleine air* approach, as well as for the more contemplative and introspective values that go into producing a work of art.

It is certainly a pleasure to see how varied and diverse oil painting has become in recent years. Often one hears that *the trouble with American art today is that there is no dominant direction, no prevailing consensus or "school."* In my opinion, this is not a problem; it is an advantage. Today, all works of quality are accepted and supported regardless of genre. All too often, a dominant direction in painting comes at the cost of all other directions. This new acceptance is a much healthier environment for art.

Our task, then, was to be true to this diversity and—our personal preferences notwithstanding—to reflect the art being produced in America today.

—Tom Nicholas

Tom Nicholas, N.A., A.W.S., D.F.
Daybreak, Lisbon
36" x 24" (84 cm x 56 cm)

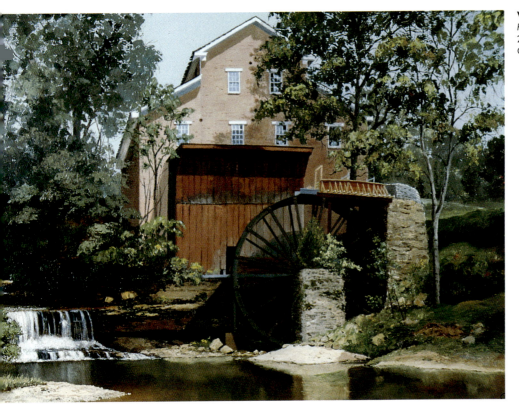

Wilma Wethington
Falls Mill
29" x 40" (73.7 cm x 101.6 cm)
Canvas

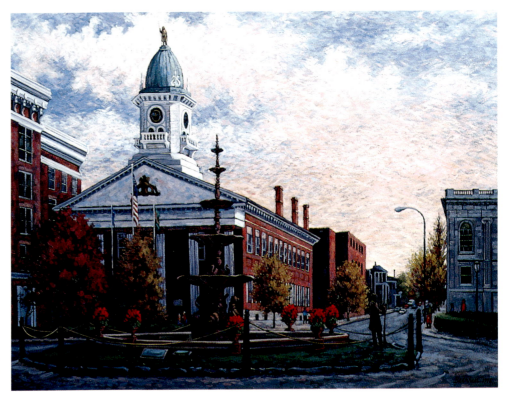

Jeffrey L. Barnhart
Memorial Square-Chambersburg, PA
36" x 48" (91.4 cm x 121.9 cm)
Stretched canvas

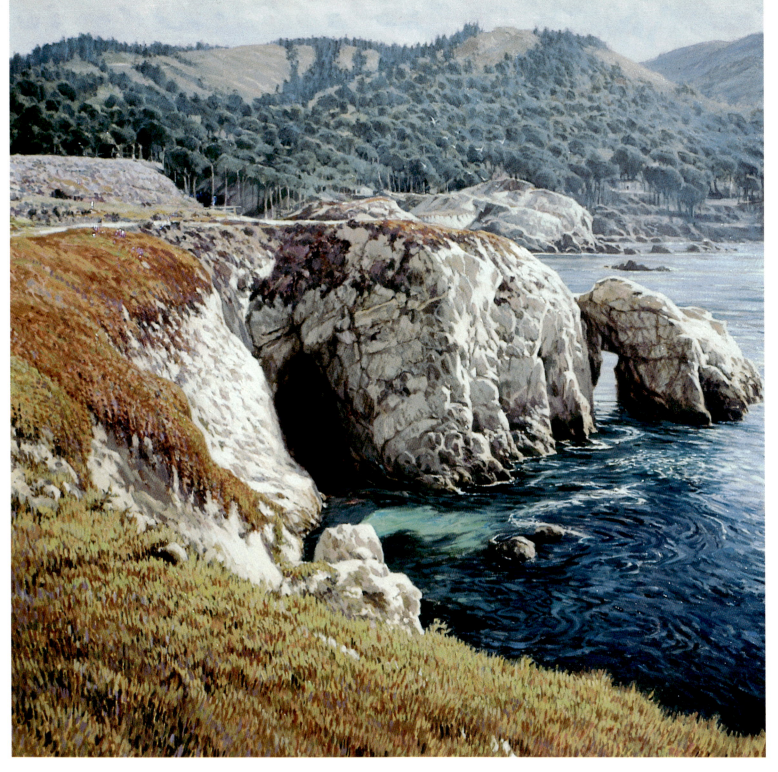

Tony Eubanks
China Cove
36" x 36" (91.4 cm x 91.4 cm)
Antwerp linen

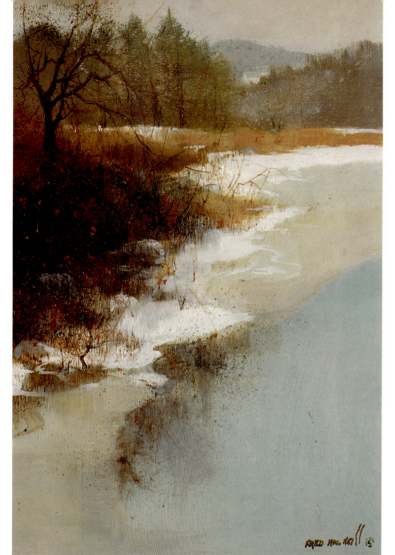

Fred MacNeill
From the Bridge
16" x 12" (40.6 cm x 30.5 cm)
Board

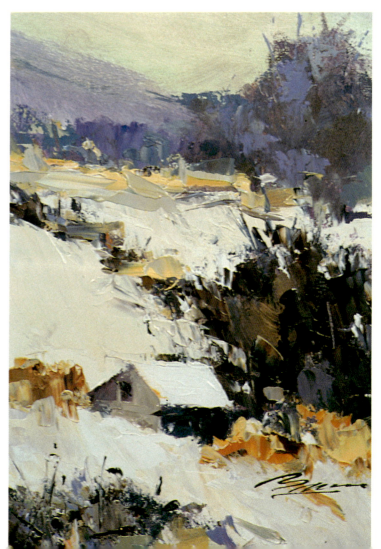

Jann T. Bass
High Fall
12" x 8" (30.5 cm x 20.3 cm)
Gesso-primed composition board

Anne Page
Mountain Goats on the Edge
36" x 28" (91.4 cm x 71.1 cm)
Canvas

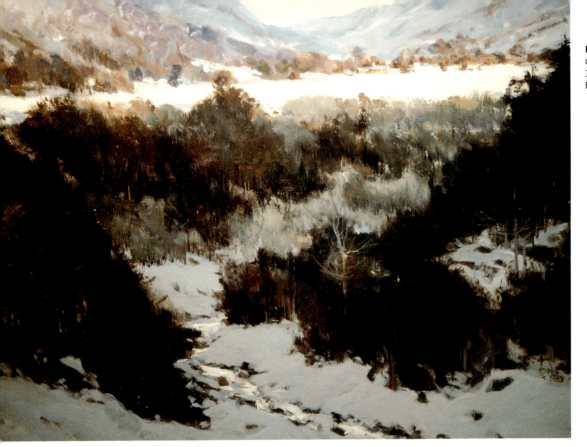

Bogomir Bogdanovic
Grand Canyon of Pennsylvania
36" x 48" (91.4 cm x 121.9 cm)
Board

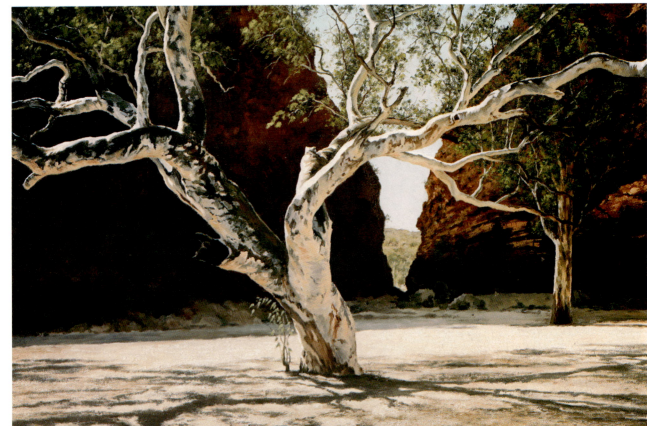

Stephen G. Mollison
Majestic Central Australia
(Simpson's Gap)
24" x 30" (61 cm x 76.2 cm)
Fredrix canvas board

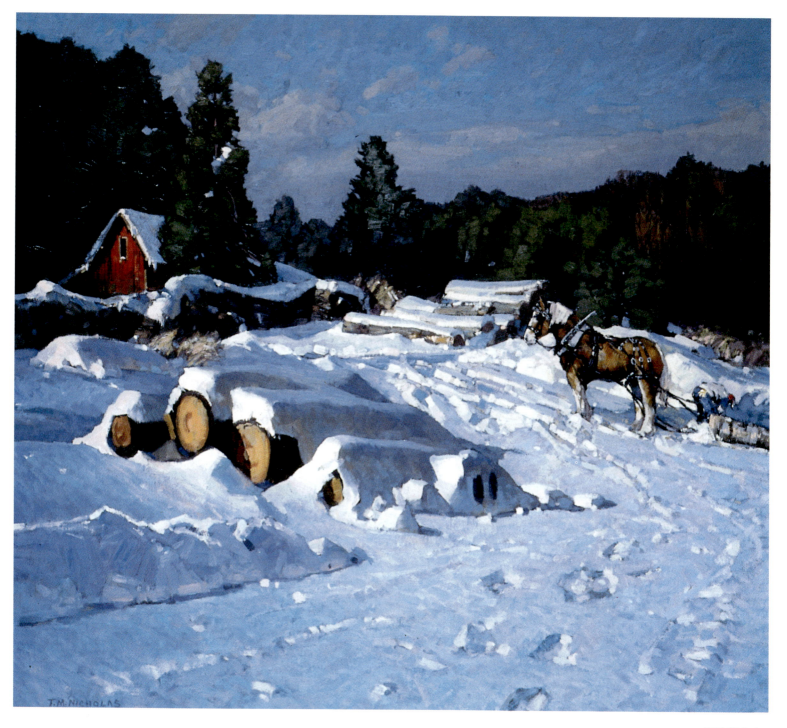

T. M. Nicholas
Days End, Vermont
36" x 40" (91.4 cm x 101.6 cm)
Linen

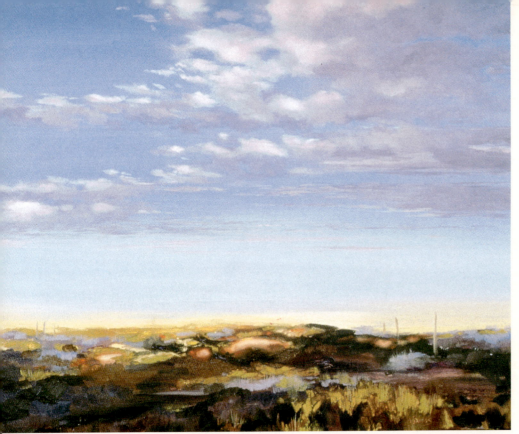

Tania Dibbs
Denis Horizon
32" x 40" (81.3 cm x 101.6 cm)
Canvas

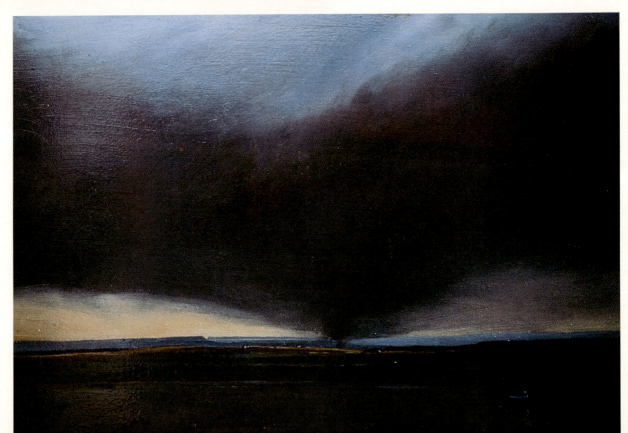

David B. Young
Twister
25" x 33" (63.5 cm x 83.8 cm)
Canvas

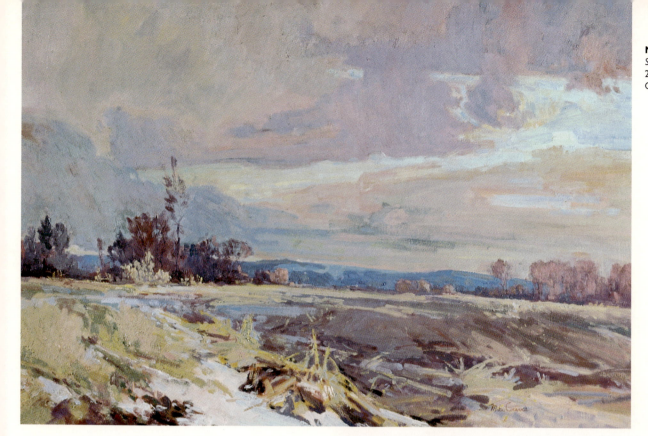

Michael Graves
Storm Coming
20" x 28" (50.8 cm x 71.1 cm)
Oil-primed linen canvas

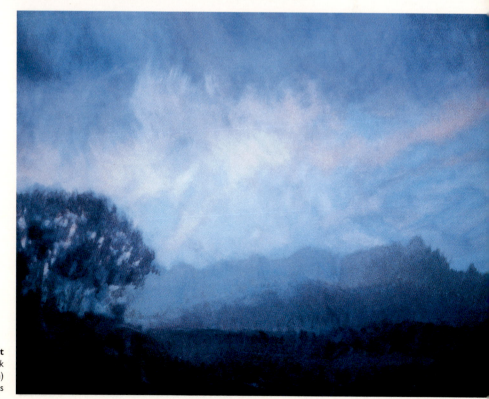

Scott Bennett
Pastoral/Dusk
36" x 54" (91.4 cm x 137.1 cm)
Canvas

13

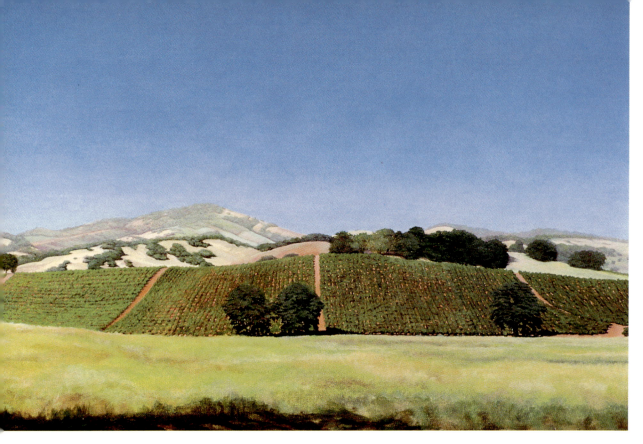

Kevin M. Donahue
Sonoma Memory
12" x 18" (30.5 cm x 45.7 cm)
Oil-primed linen canvas

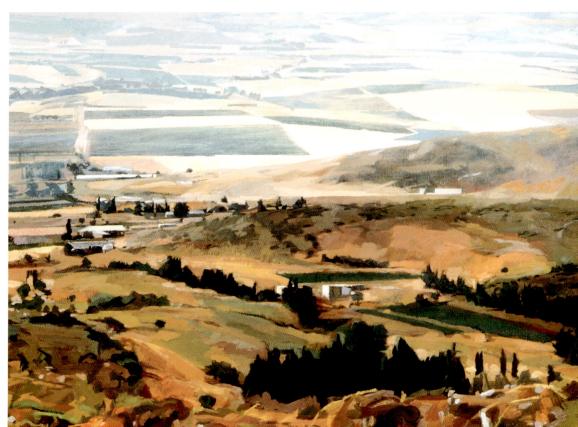

Periklis Pagratis
Landscape
24" x 36" (61 cm x 91.4 cm)
Canvas

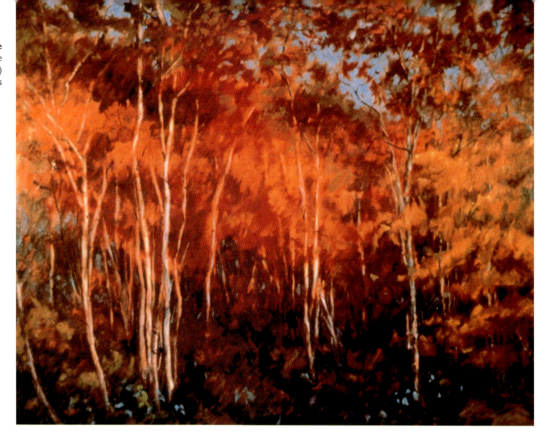

Beatrice Goldfine
Autumn Orange
48" x 60" (121.9 cm x 152.4 cm)
Canvas

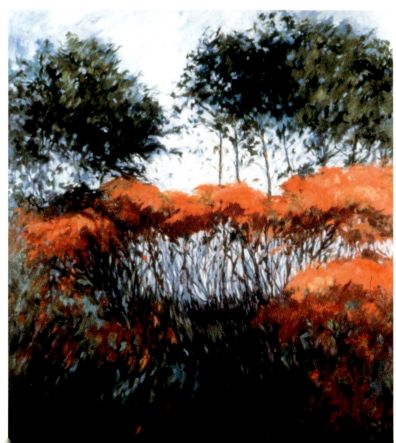

Beatrice Goldfine
Conference
54" x 50" (137.2 cm x 127 cm)
Canvas

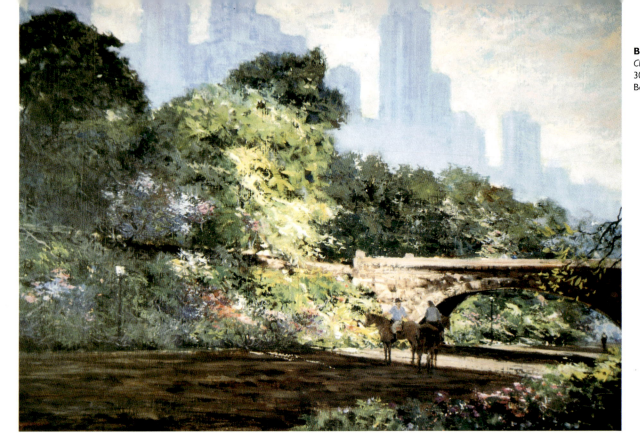

Bogomir Bogdanovic
Chat on Bridle Path
30" x 40" (76.2 cm x 101.6 cm)
Board

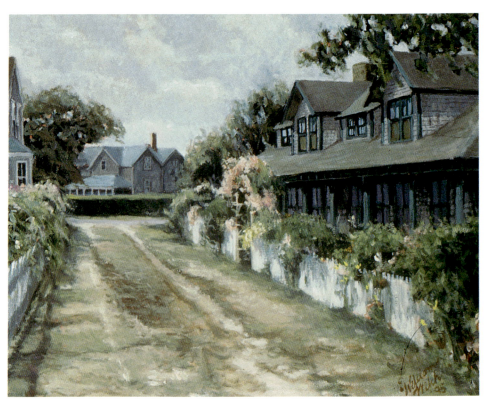

William Welch
Summer Solace
14" x 21" (35.6 cm x 53.3 cm)
Linen

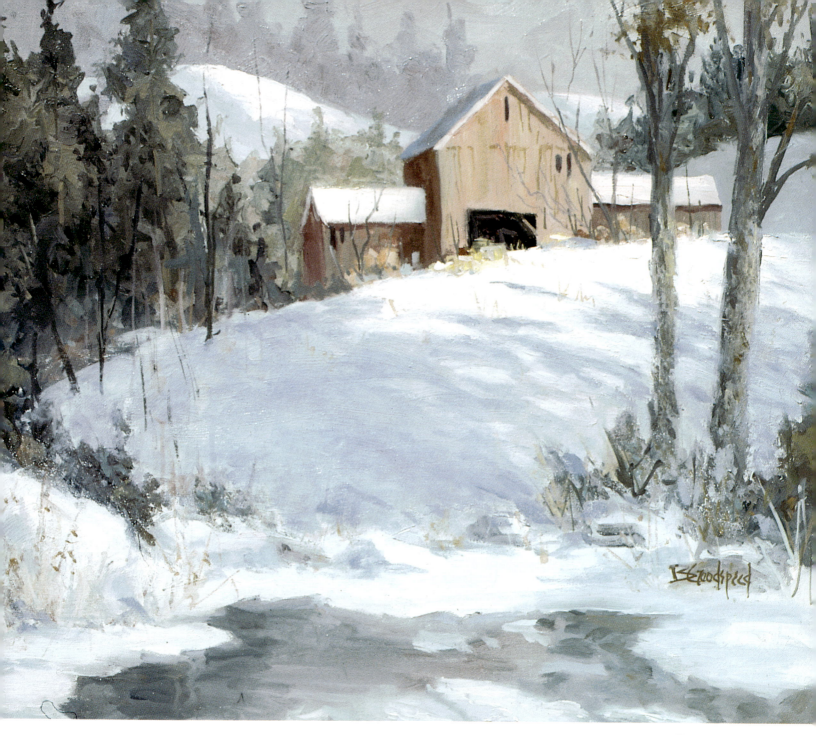

Barbara Goodspeed
Near the Brook
20" x 24" (50.8 cm x 61 cm)
Canvas

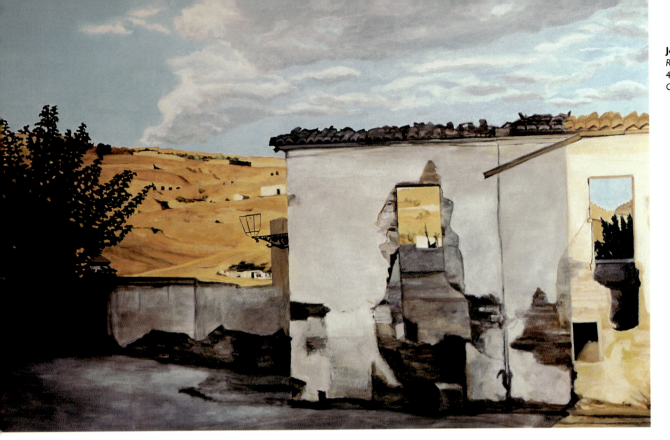

Jeannette Murray
Ruins, Granada
40" x 60" (101.6 cm x 152.4 cm)
Canvas

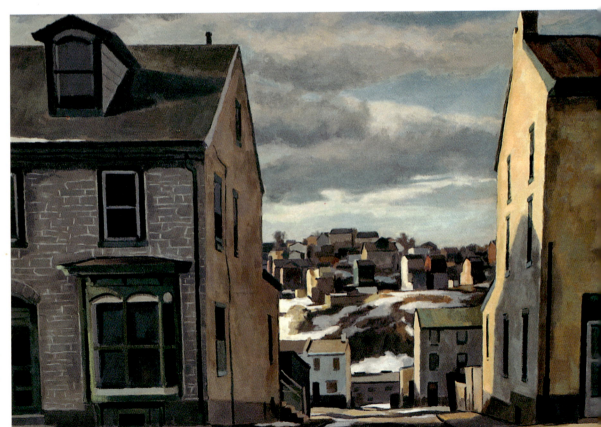

Giovanni Martino
Morning Clouds
42" x 60" (106.7 cm x 152.4 cm)
Linen canvas

18

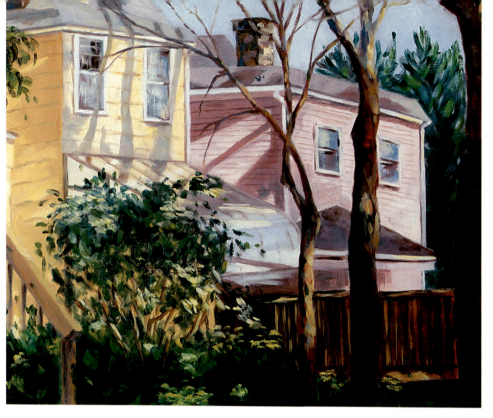

Elissa Paystank
Catherine Lane
25" x 29" (63.5 cm x 73.7 cm)
Canvas

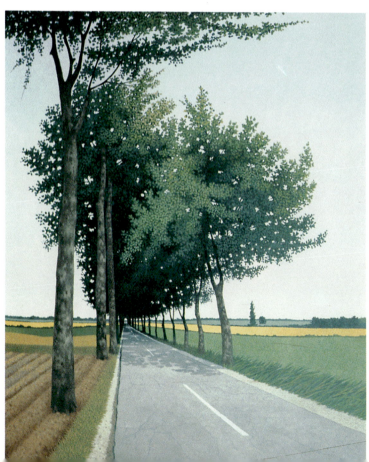

Rolland Golden
French Way
44" x 34" (111.8 cm x 86.4 cm)
Canvas

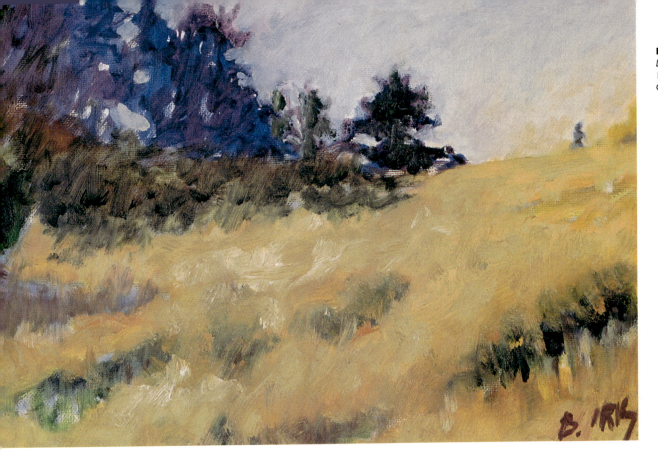

Bonnie Iris
Dog Days of Summer
12" x 16" (30.5 cm x 40.6 cm)
Canvas panel

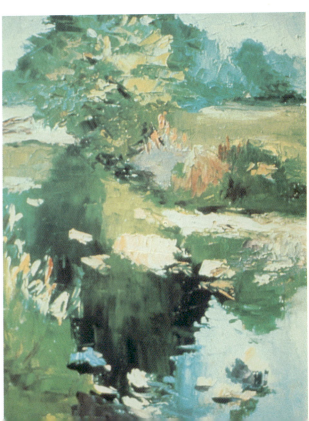

Mary Poulos
Goffle Brook
25" x 21" (63.5 cm x 53.3 cm)
Belgian canvas

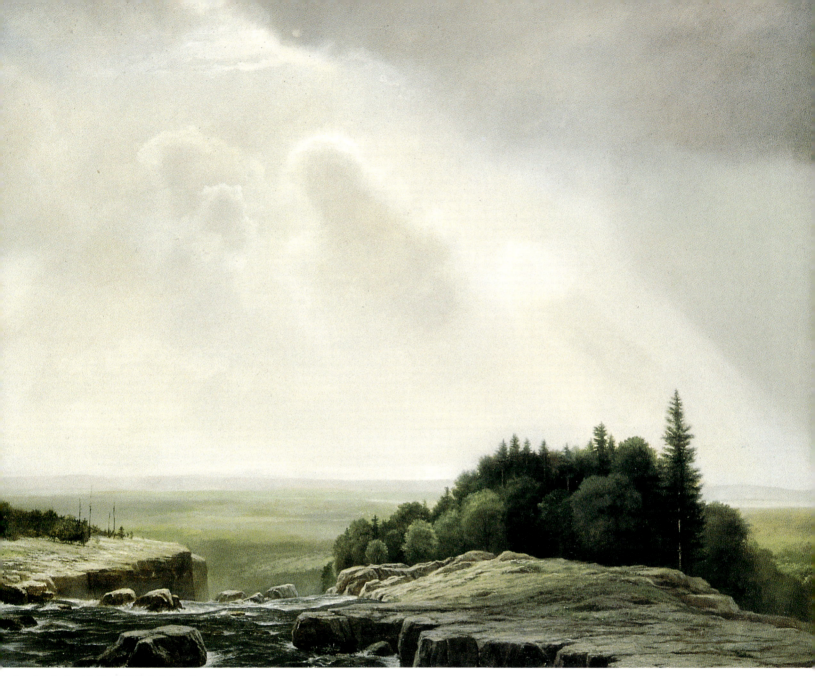

From the collection of Curtis and Julie Grelle, Indianapolis

Mark Flickinger
Highland Stream
36" x 48" (91.4 cm x 121.9 cm)
Canvas

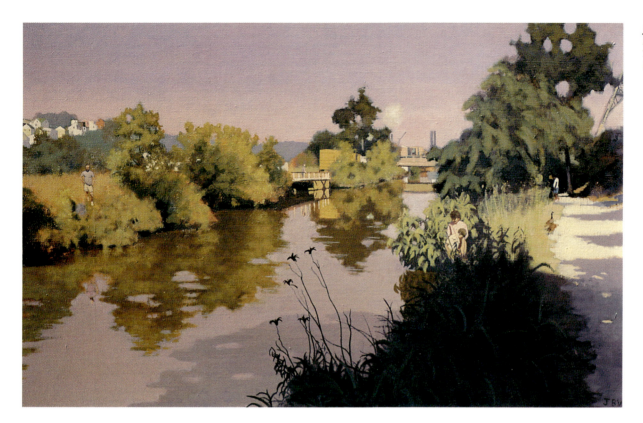

Jim Williams
Daylilies
22" x 66" (55.9 cm x 91.4 cm)
Linen canvas

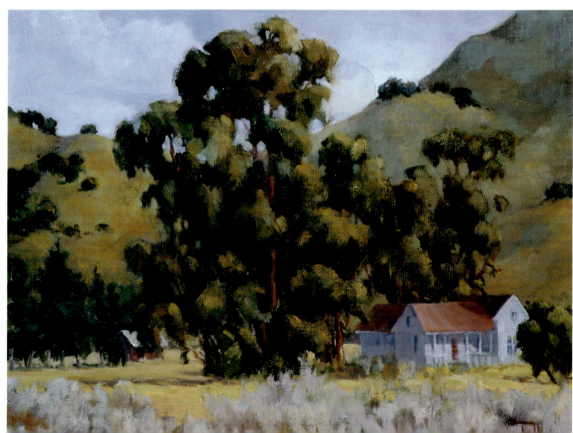

Libby Tolley
Ranch at the Base of Bishop's Peak
14" x 18" (35.6 cm x 45.7 cm)
Linen on masonite panel

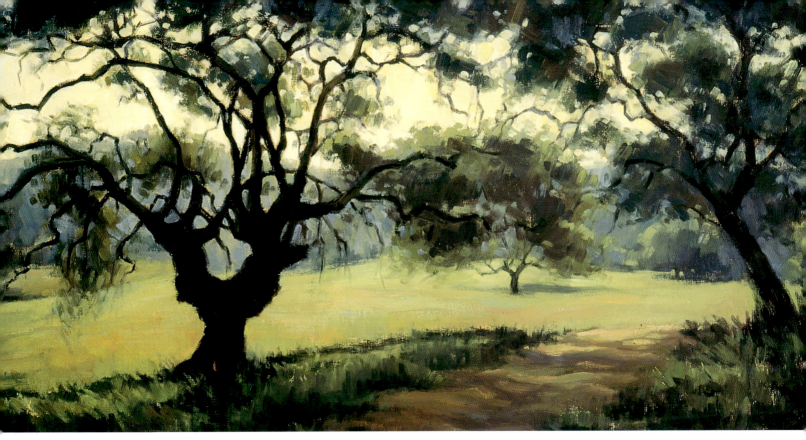

Kristi Krafft
Late Afternoon Glow Through the Oaks
16" x 30" (40.6 cm x 76.2 cm)
Linen

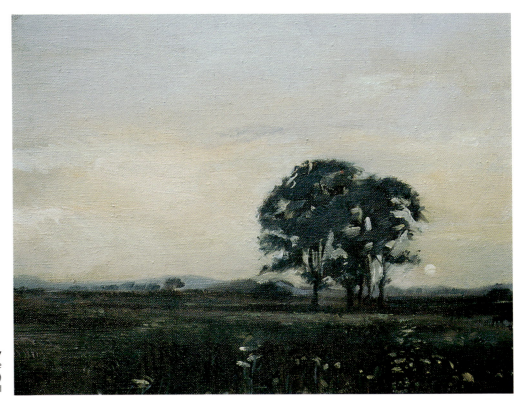

Murray Muldofsky
Mississippi Landscape
10" x 18" (25.4 cm x 20.3 cm)
Canvas mounted on panel

23

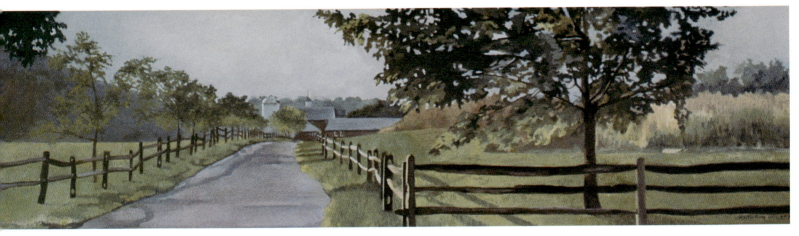

Kathryn S. Heuzey
Uplands Farm Early Autumn
13" x 42"
(33 cm x 106.7 cm)
Canvas

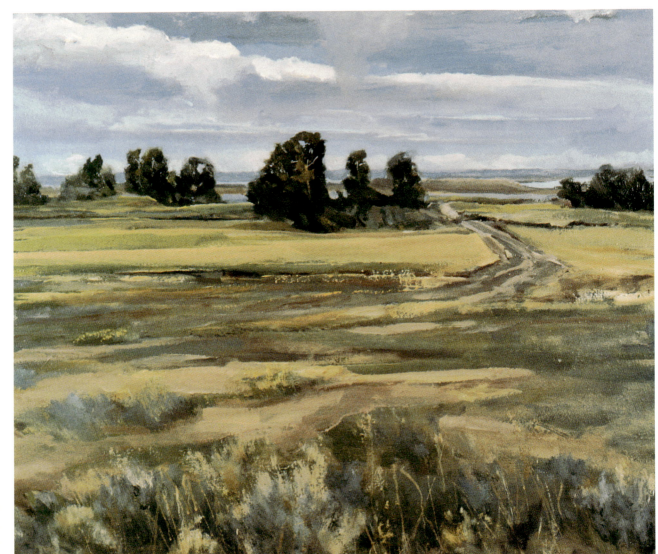

David B. Young
Road to the Lake
29" x 36"
(73.7 cm x 91.4 cm)
Canvas

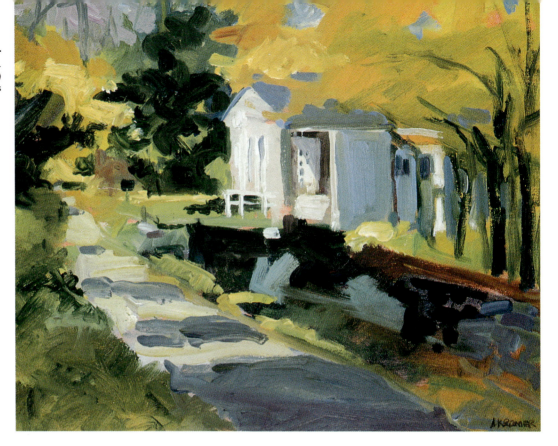

Ann Kromer
Nod Hill Rd.
16" x 20" (40.6 cm x 50.8 cm)
Canvas

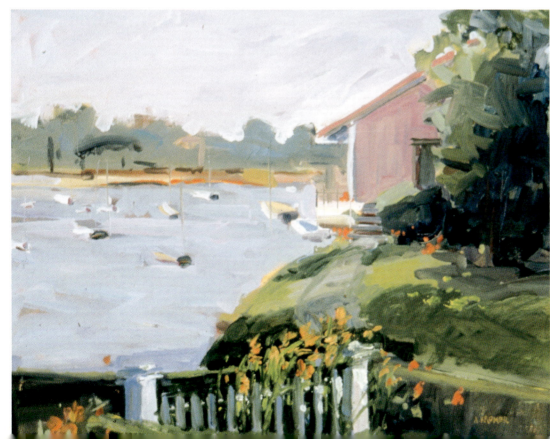

Ann Kromer
Norwalk Yacht Club
16" x 20" (40.6 cm x 50.8 cm)
Canvas

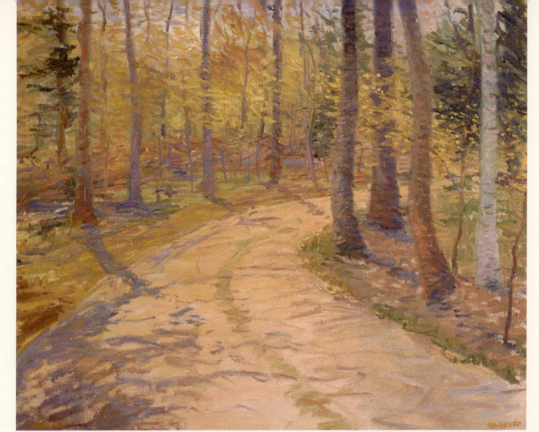

Ira A. Barkoff
My Road
28" x 33" (71.7 cm x 83.8 cm)
Linen canvas

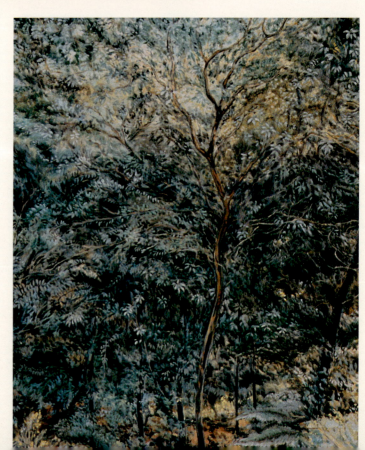

Christine Hanlon
The Madrone
30" x 24" (76.2 cm x 61 cm)
Canvas duck

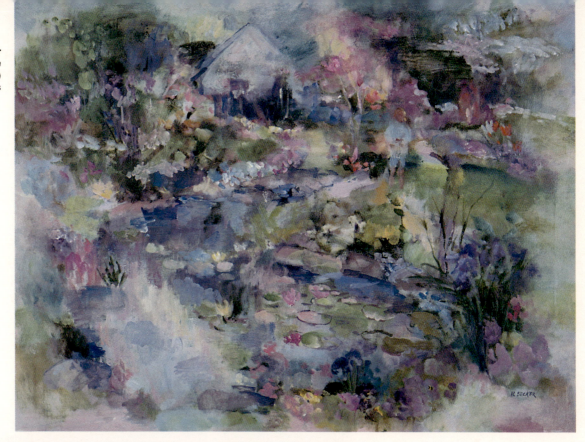

Natalie Becker
Spring Garden
28" x 36" (71.1 cm x 91.4 cm)
Belgian linen canvas

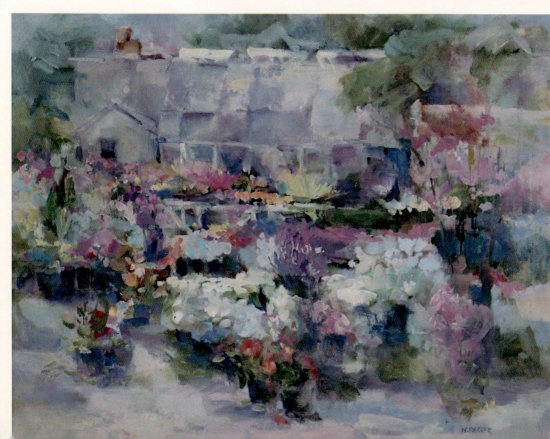

Natalie Becker
Florist's Garden
24" x 30" (61 cm x 76.2 cm)
Belgian linen canvas

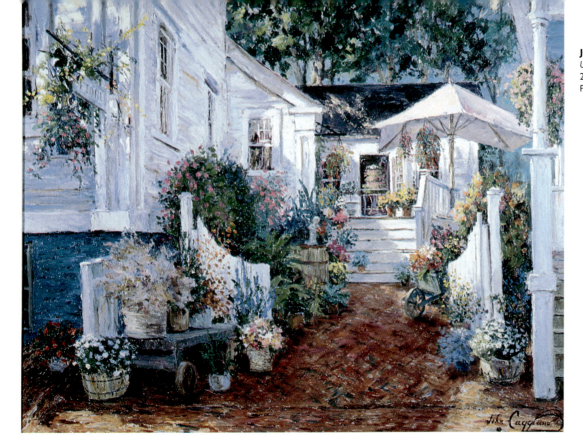

John Caggiano
Un Bello Giordano dei Fiori
24" x 30" (61 cm x 76.2 cm)
Primed masonite

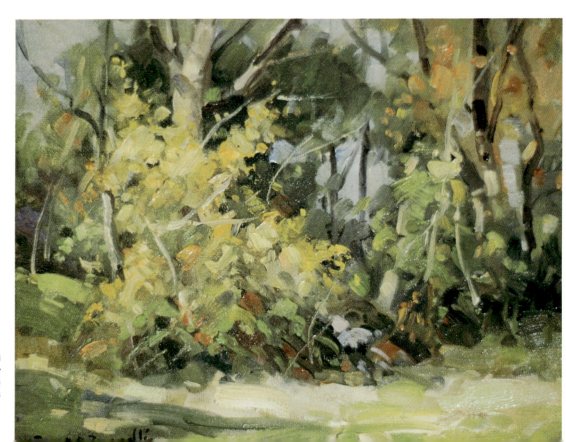

Frank E. Zuccarelli
October Hickory
8" x 10" (20.3 cm x 25.4 cm)
Canvas

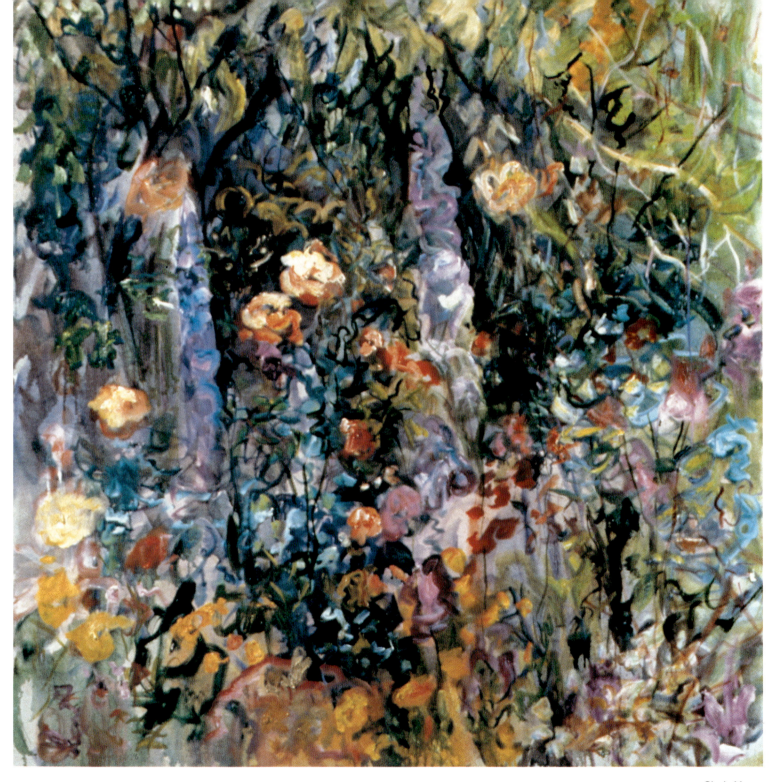

Gloria Moses
Garden Series #10
48" x 48" (121.9 cm x 121.9 cm)
Canvas

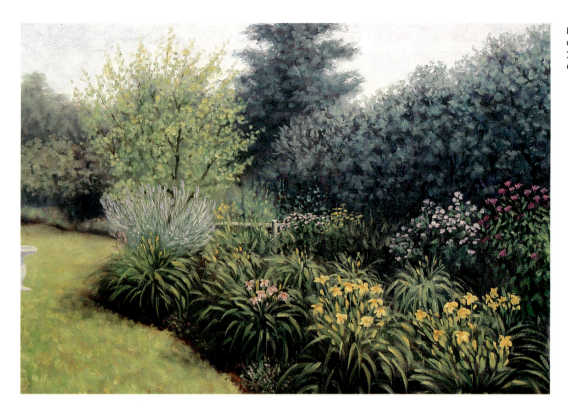

Kathleen Kalinowski
Garden Path
24" x 30" (61 cm x 76.2 cm)
Canvas

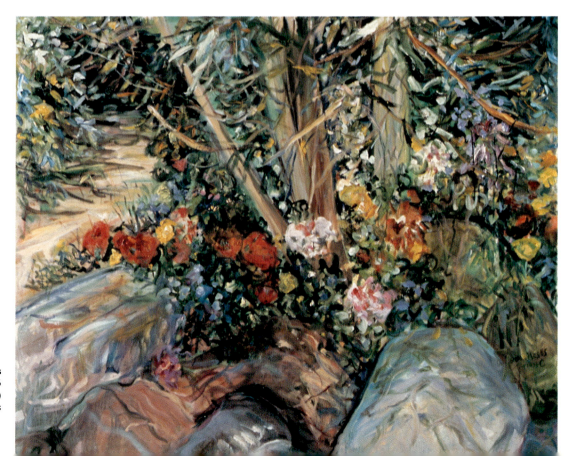

Gloria Moses
Garden Series #6
48" x 60" (121.9 cm x 152.4 cm)
Canvas

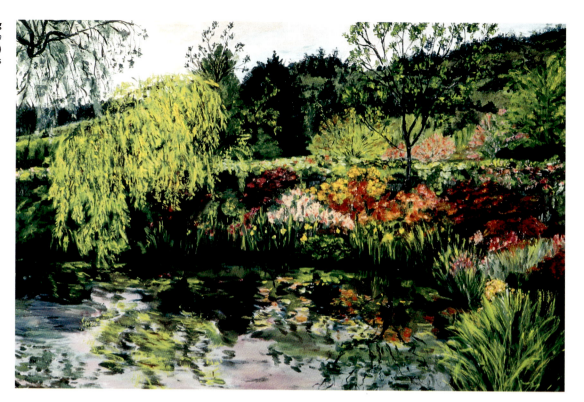

Agnes Manning
Monet's Garden
24" x 36" (61 cm x 91.4 cm)
Canvas

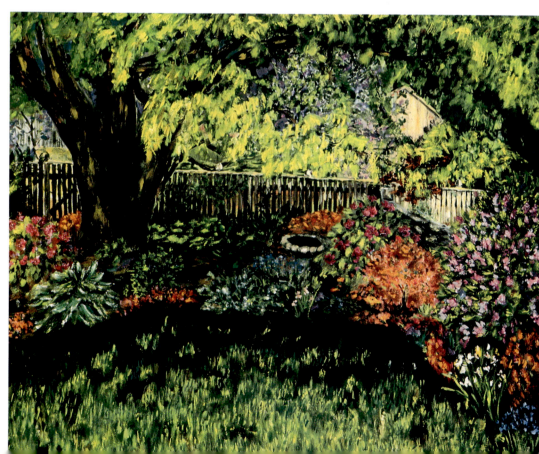

Agnes Manning
Betty's Garden
28" x 28" (71.1 cm x 71.1 cm)
Canvas

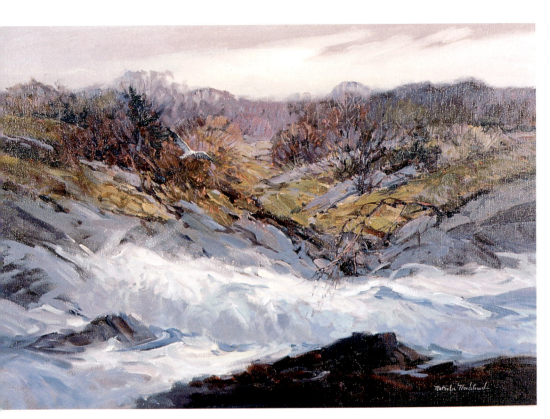

Nathalie J. Nordstrand
Autumn at Folly Cove
24" x 36" (61 cm x 91.4 cm)
Linen

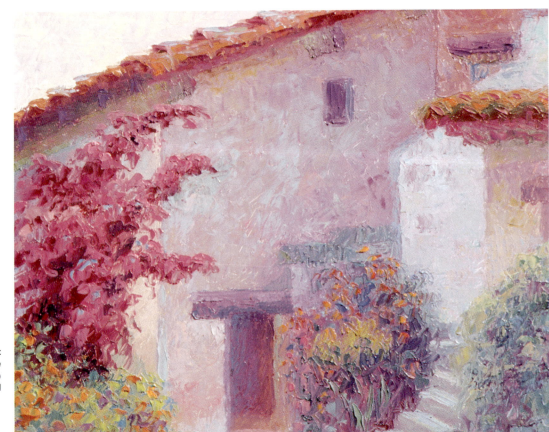

Susan Sarback
Carmel Mission
11" x 14" (27.9 cm x 35.6 cm)
Masonite board

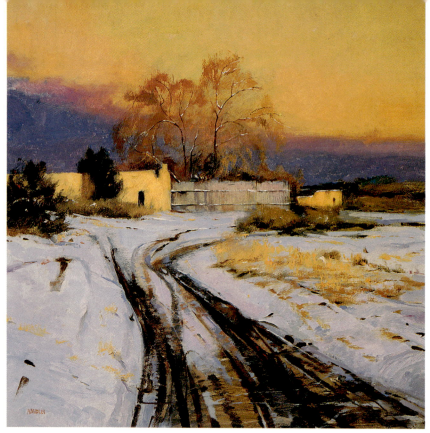

Albert Handell
Mid-Winter
24" x 24" (61 cm x 61 cm)
Gesso-primed masonite panel

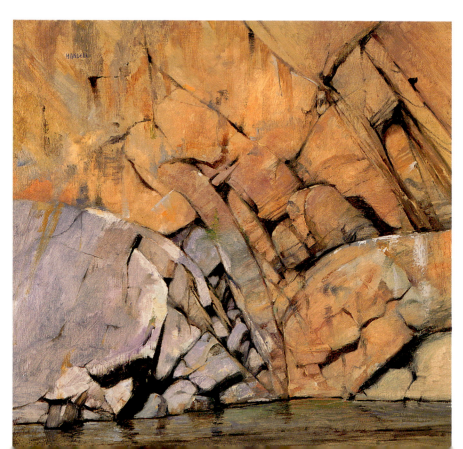

Albert Handell
The Rhythm of the Rocks
24" x 24" (61 cm x 61 cm)
Gesso-primed masonite panel

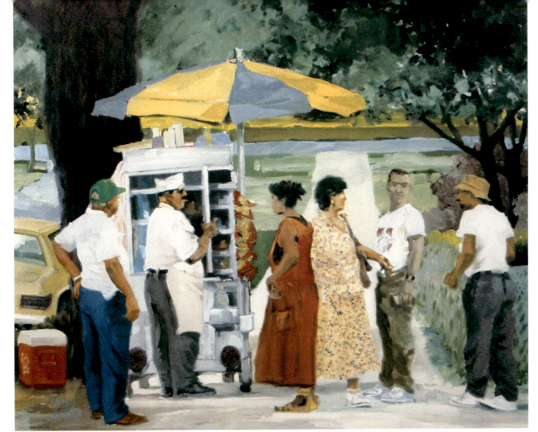

Donald L. Berry
Red Hots
20" x 23" (50.8 cm x 58.4 cm)
Masonite

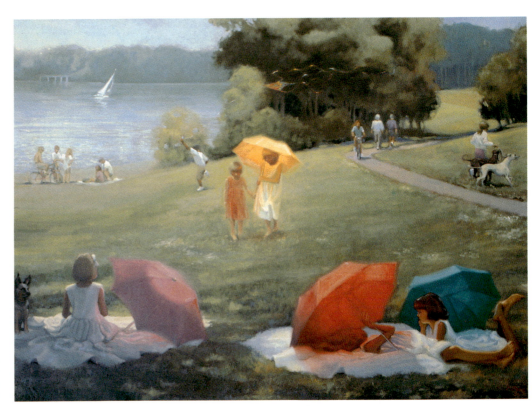

Ann Boyer LePere
Sunday Afternoon
40" x 60" (101.6 cm x 152.4 cm)
Linen

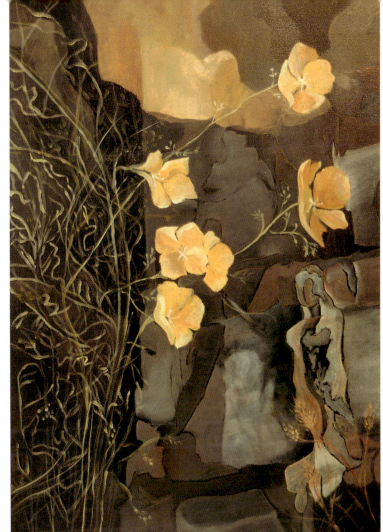

S.H. Kale
Madonna of the Rocks
20" x 16" (50.8 cm x 40.6 cm)
Canvas medium duck

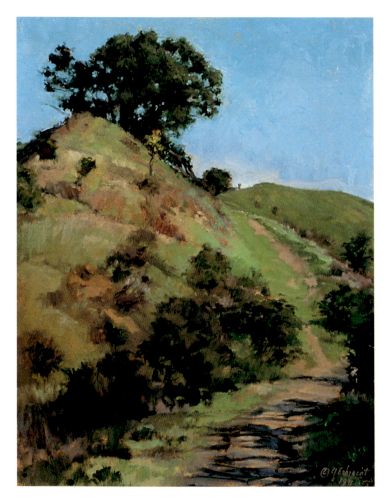

Bob Gerbracht
Contra Costa Spring
20" x 16" (50.8 cm x 40.6 cm)
Canvas

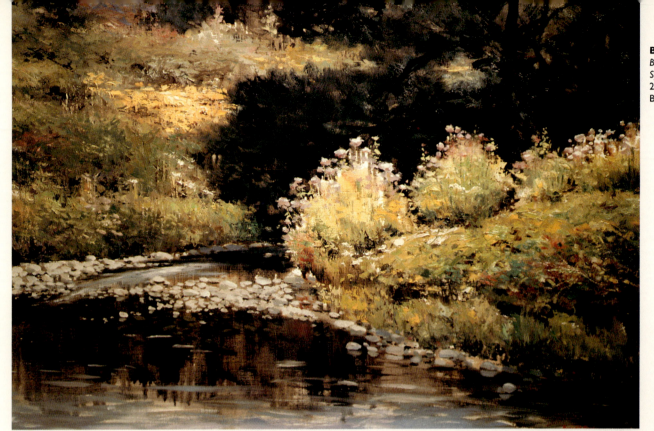

Bogomir Bogdanovic
*Beginning of October
Symphony II*
24" x 36" (61 cm x 91.4 cm)
Board

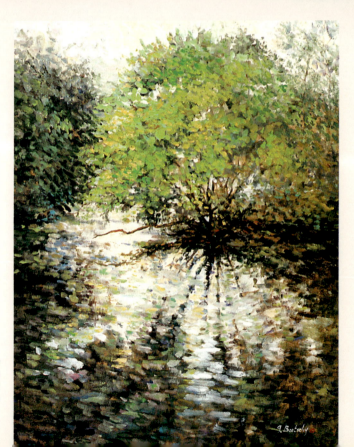

Gerri Brutschy
Reflections
28" x 22" (71.1 cm x 55.9 cm)
Stretched canvas

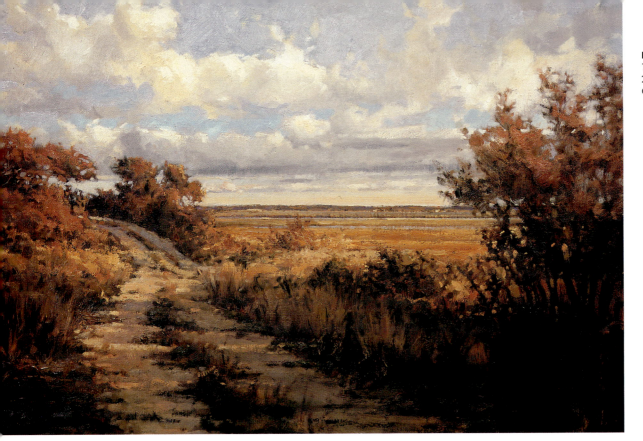

Frank P. Coras
The Road to Sankaty
24" x 36" (61 cm x 91.4 cm)
Canvas fixed to board

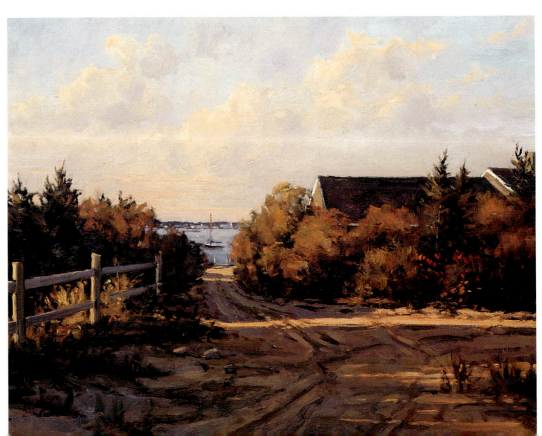

Frank P. Coras
Late Light in Monomoy
24" x 30" (61 cm x 76.2 cm)
Canvas fixed to board

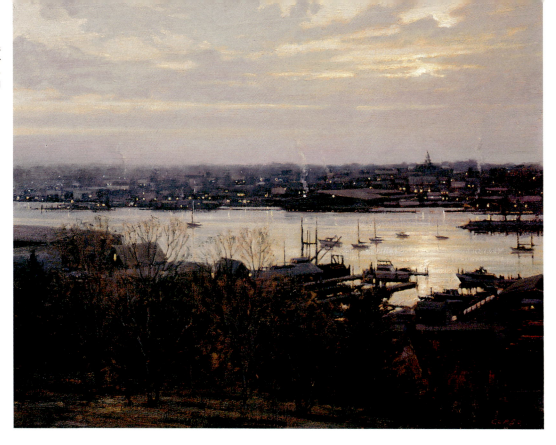

Frank P. Coras
Moonrise Over Gloucester
24" x 30" (61 cm x 76.2 cm)
Canvas fixed to board

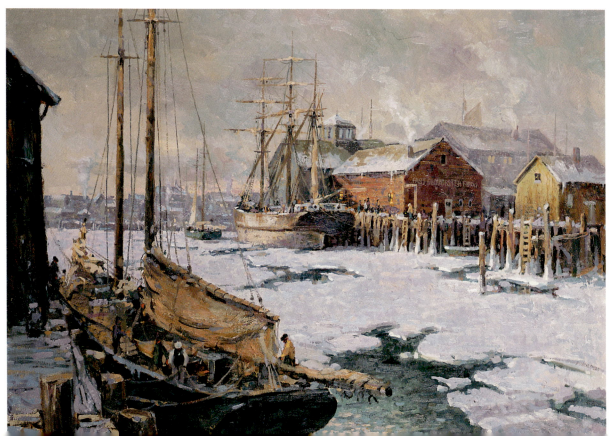

Donald Mosher
Gloucester Freeze Up
30" x 40" (76.2 cm x 101.6 cm)
Linen canvas

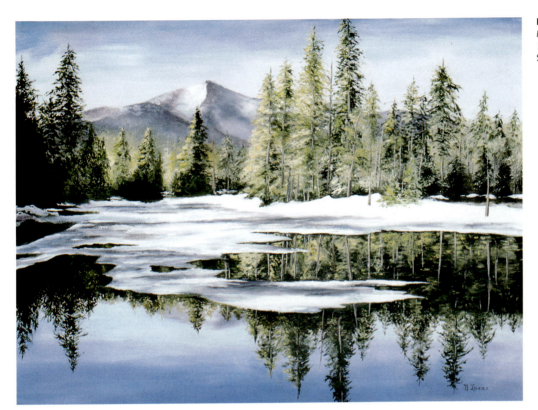

Noma Lucas
Reflections
16" x 20" (40.6 cm x 50.8 cm)
Stretched canvas

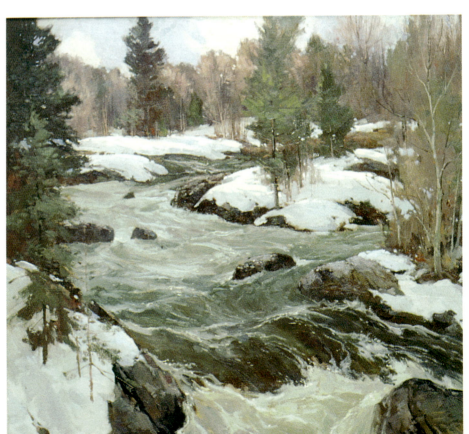

Bernard Corey
Spring Thaw
24" x 22" (61 cm x 55.9 cm)
Linen canvas

Ward P. Mann
Cape Pond Ice House
24.5" x 32.5" (62.2 cm x 82.6 cm)
Panel

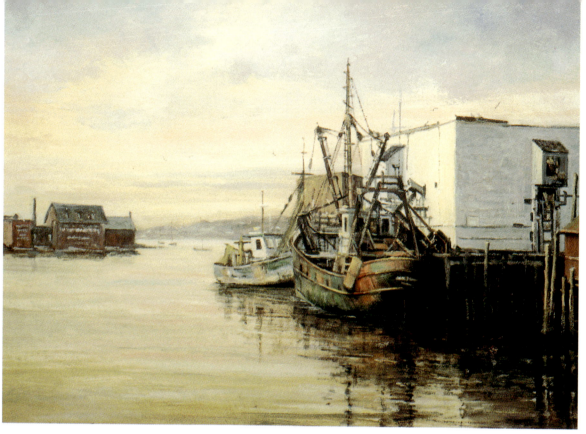

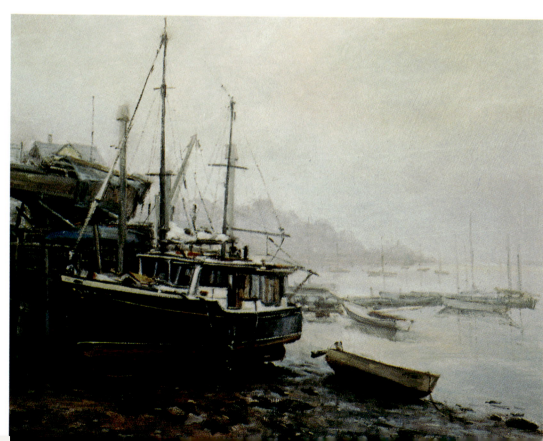

Ward P. Mann
Rocky Neck
22" x 28" (55.9 cm x 71.1 cm)
Panel

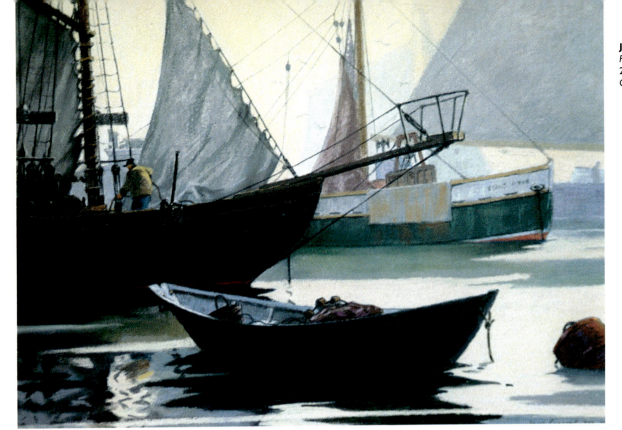

Jack Coggins
Fisherman at Anchor
20" x 26" (50.8 cm x 66 cm)
Canvas on board

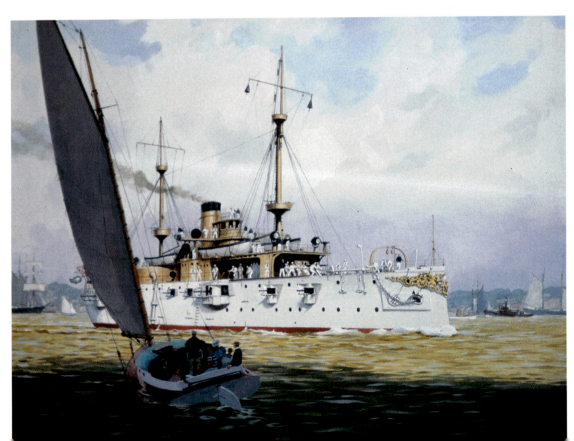

Jack Coggins
The First "Texas"
28" x 36" (71.1 cm x 91.4 cm)
Canvas on board

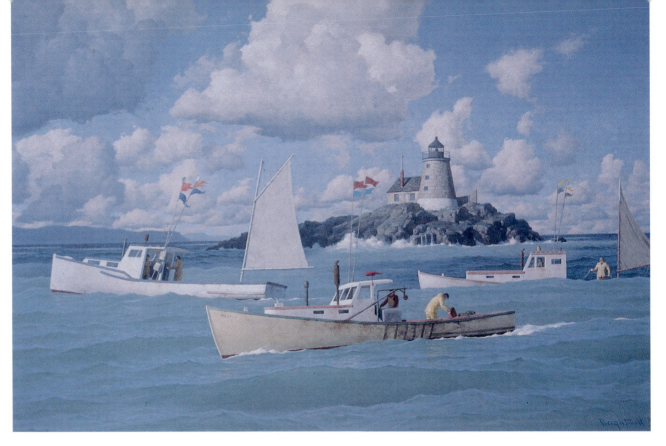

Walter Brightwell
Return of the Hakers
24" x 36"
(61 cm x 91.4 cm)
Panel

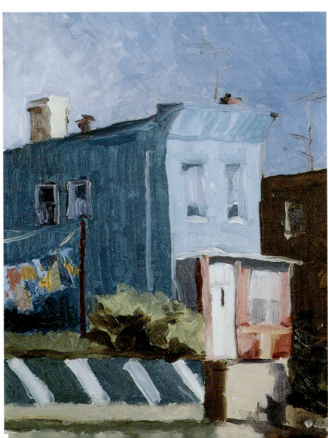

Jeff Pavone
View From Studio
11" x 8"
(27.9 cm x 20.3 cm)
Masonite

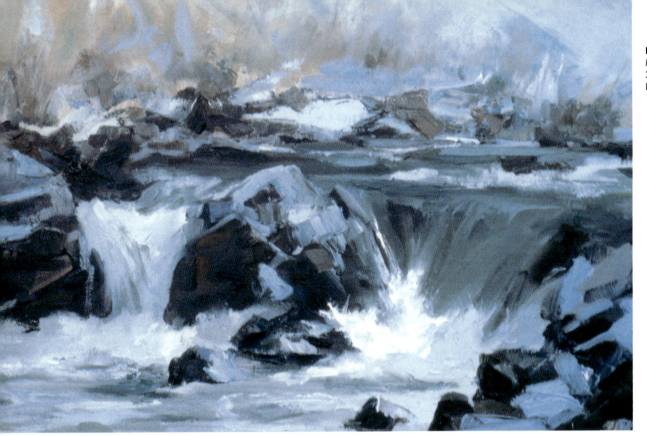

David Garrison
Rapids & Rocks
20" x 30" (50.8 cm x 76.2 cm)
Linen canvas

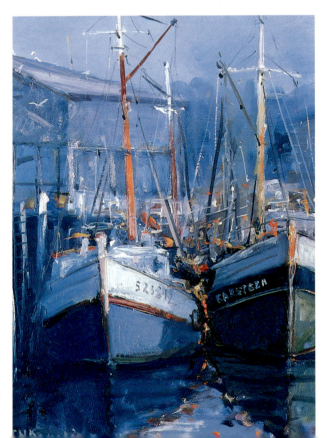

Ivan N. Kamalic
Last Light
20" x 14" (50.8 cm x 35.6 cm)
Oil-primed masonite

Helen H. Carmichael
Bass Head Lighthouse
28" x 22"
(71.1 cm x 55.9 cm)
Stretched canvas

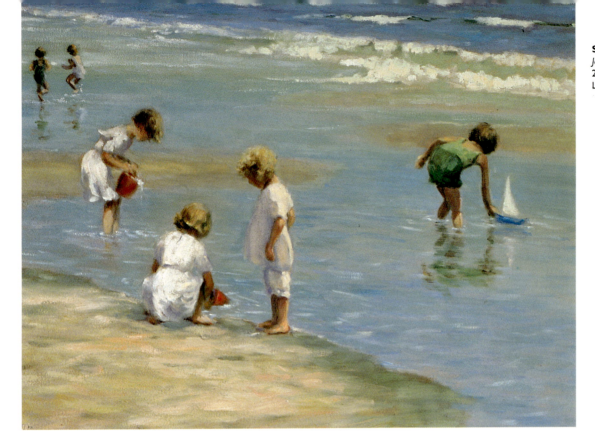

Shirley Cean Youngs
Joy
24" x 30" (61 cm x 76.2 cm)
Linen

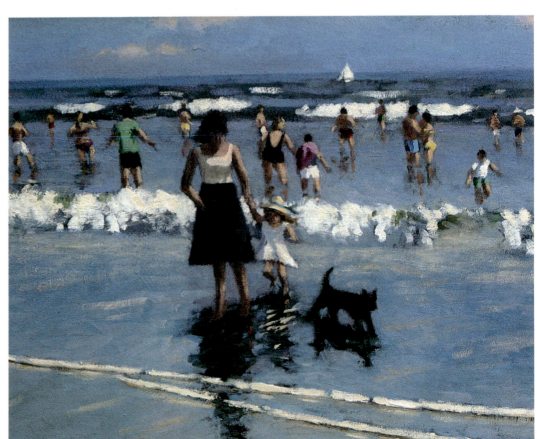

Bruce Backman Turner
August Reflections
20" x 24" (50.8 cm x 61 cm)
Canvas

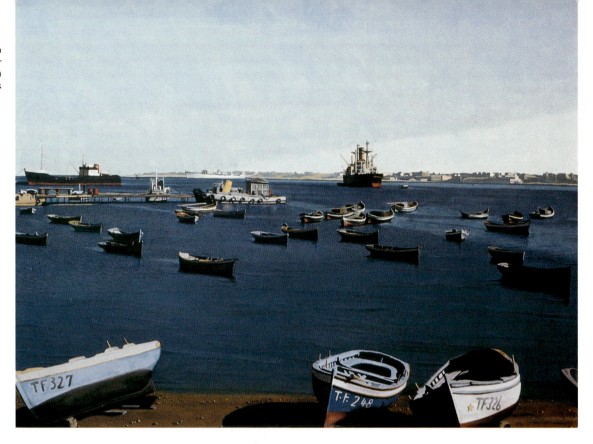

Gregory Lysun
Morning-The Harbor
32" x 42" (81.3 cm x 106.7 cm)
Canvas

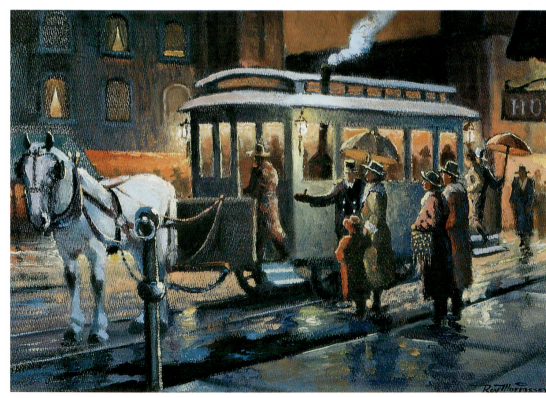

Roy Morrissey
One Horse Power
12" x 16" (30.5 cm x 40.6 cm)
Masonite

47

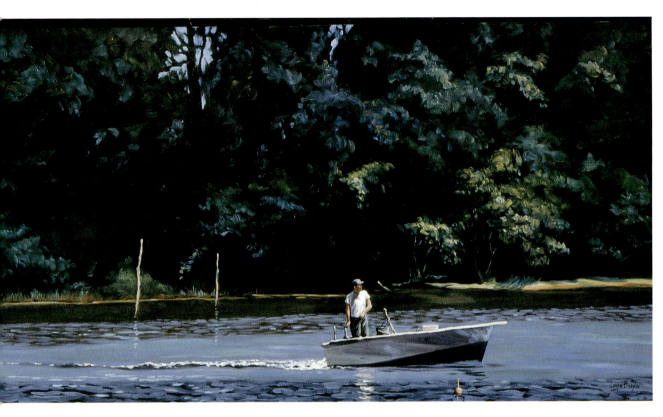

Loryn Brazier
Waterman
48" x 60" (121.9 cm x 152.4 cm)
Canvas

Walter Brightwell
George's Crew
20" x 40" (50.8 cm x 101.6 cm)
Canvas

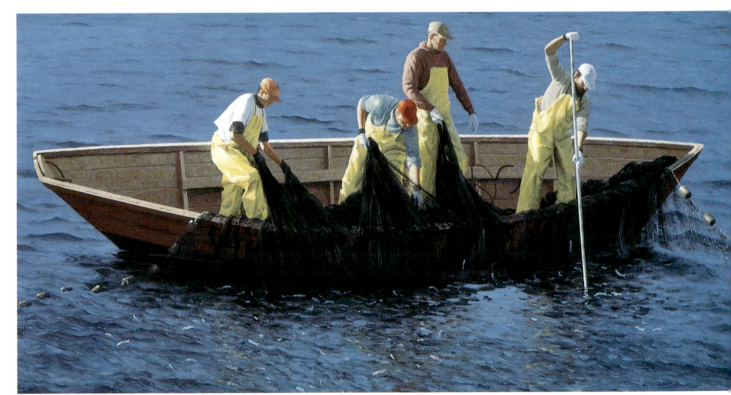

Walter Garver
At the Great Northern
40" x 30"
(101.6 cm x 76.2 cm)
Tempered masonite

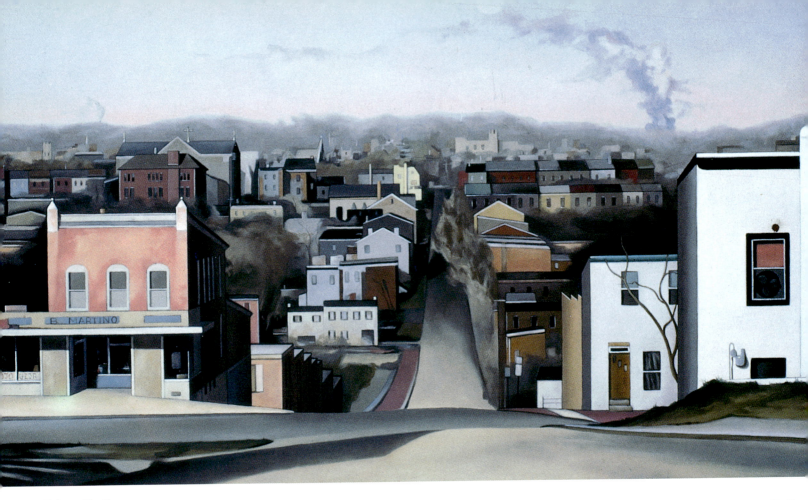

Babette Martino
Study for: Blue Moon over Three Mile Island
11.75" x 20" (29.9 cm x 50.8 cm)
Masonite panel

Lynne Lockhart
Dead Battery
22" x 16" (55.9 cm x 40.6 cm)
Canvas duck

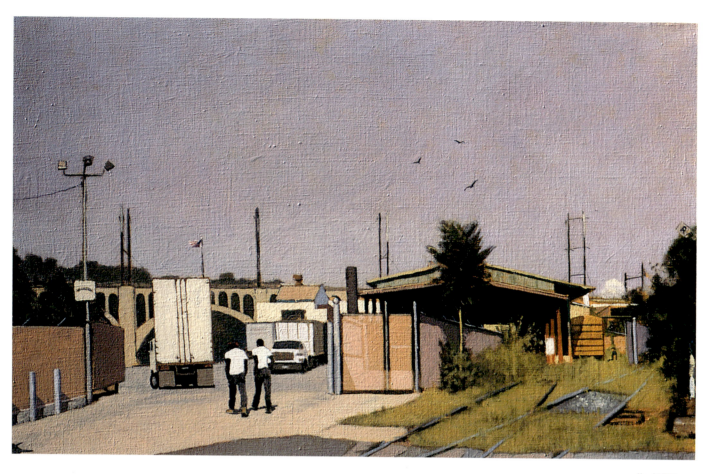

Jim Williams
The Yard
16" x 26" (40.6 cm x 66 cm)
Linen canvas

Neal Korn
Central Park III
20" x 26" (50.8 cm x 66 cm)
Canvas

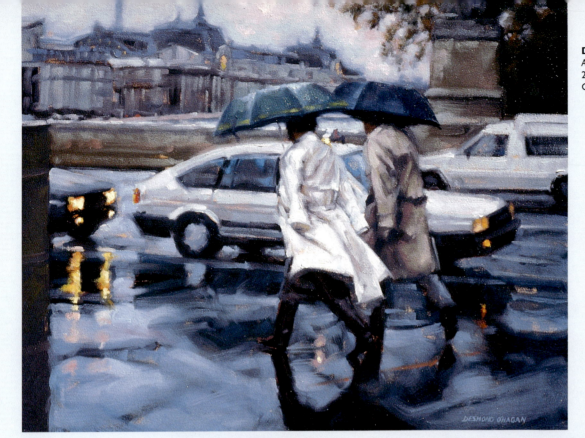

Desmond O'Hagan
After the Storm, Paris
24" x 30" (61 cm x 76.2 cm)
Canvas

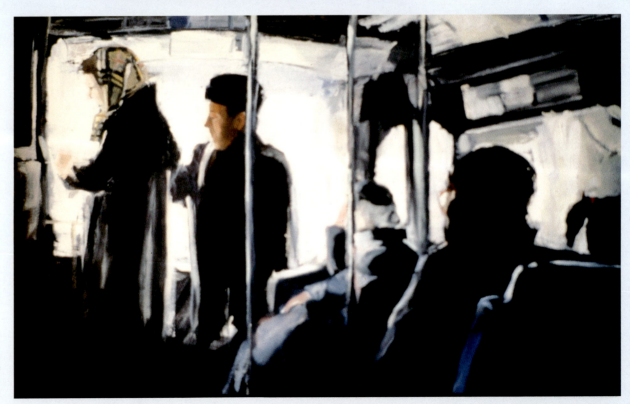

D. Wels
Passengers Boarding
28" x 48" (71.1 cm x 121.9 cm)
Canvas

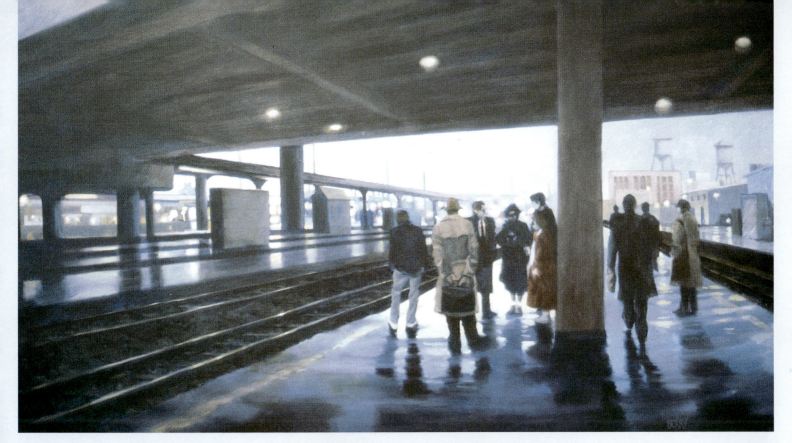

Donald L. Berry
Commuters
28" x 50" (71.1 cm x 127 cm)
Canvas

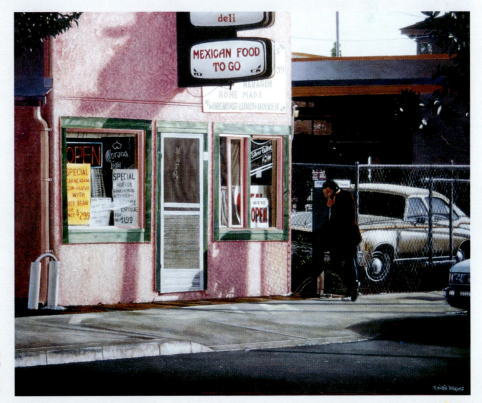

Emigdio Vasquez
The Orange Deli
24" x 30" (61 cm x 76.2 cm)
Canvas

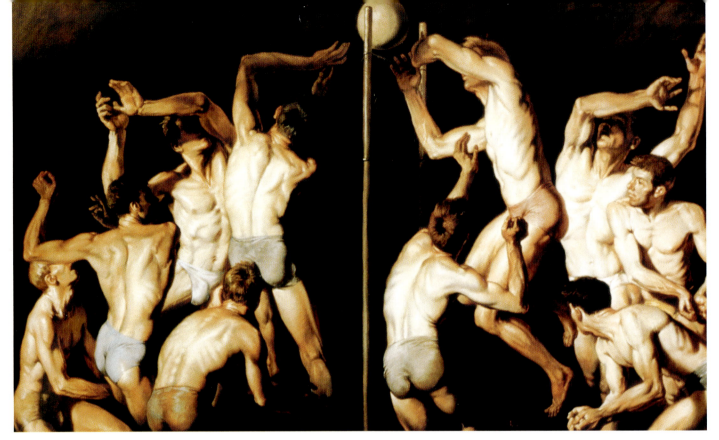

Joseph Sheppard
Volleyball
36" x 61" (91.4 cm x 154.9 cm)
Panel

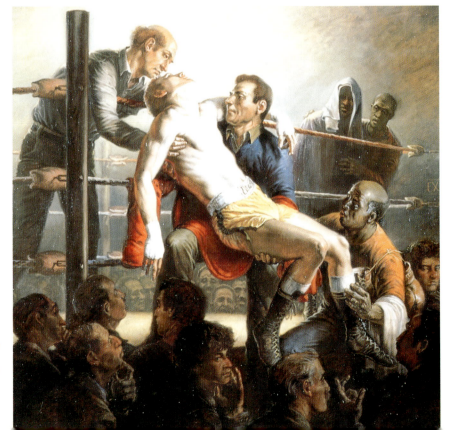

Joseph Sheppard
Descent from the Ring
60" x 60" (152.4 cm x 152.4 cm)
Canvas

Jo Sherwood
Ankara, Turkey
23" x 18" (59 cm x 45.7 cm)
Panel

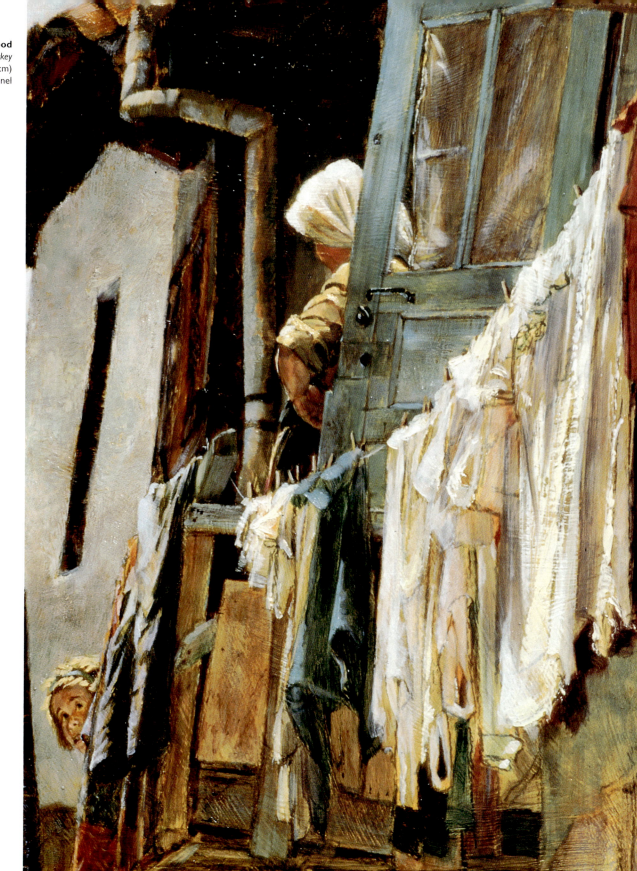

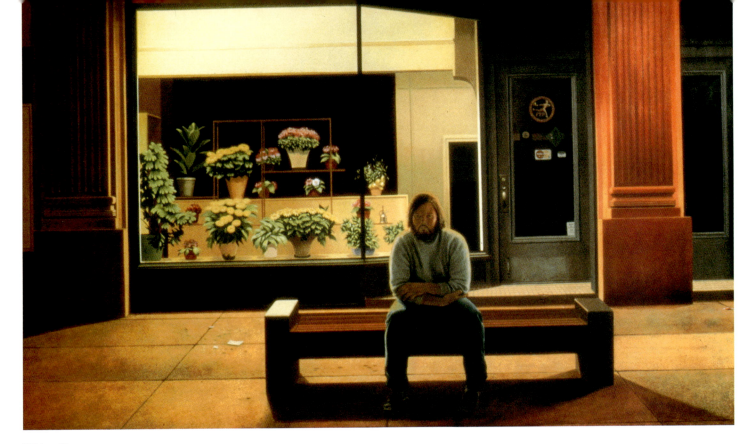

Walter Garver
Bus Stop
32" x 44" (81.3 cm x 111.8 cm)
Oil with acrylic and gesso
Tempered masonite

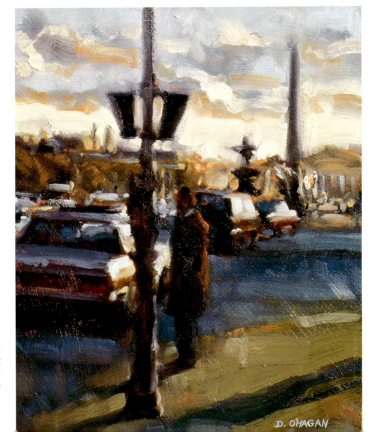

Desmond O'Hagan
Parisian Light
13" x 10" (33 cm x 25.4 cm)
Gesso-primed masonite

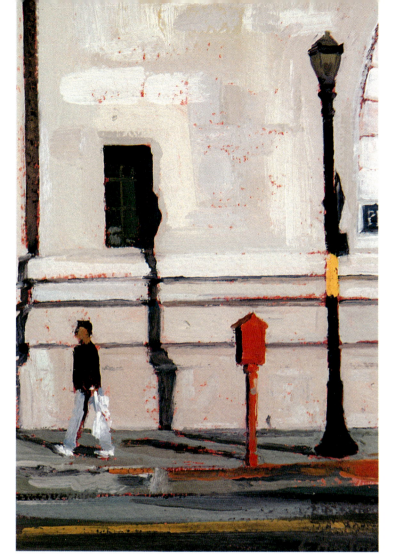

Christine Hanlon
Embarcadero
9.5" x 6.5"
(24.1 cm x 16.5 cm)
Gesso-primed medium weight paper

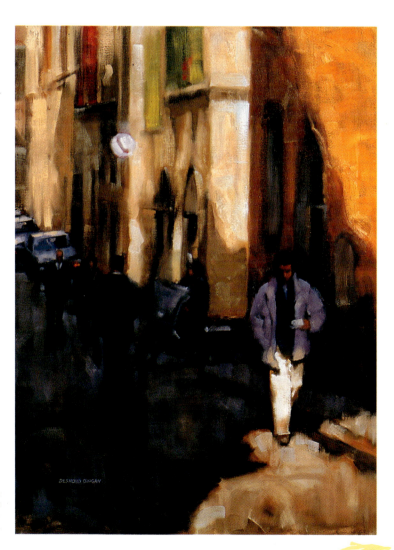

Desmond O'Hagan
Fall Shadows, Florentine Street
40" x 30" (101.6 cm x 76.2 cm)
Canvas

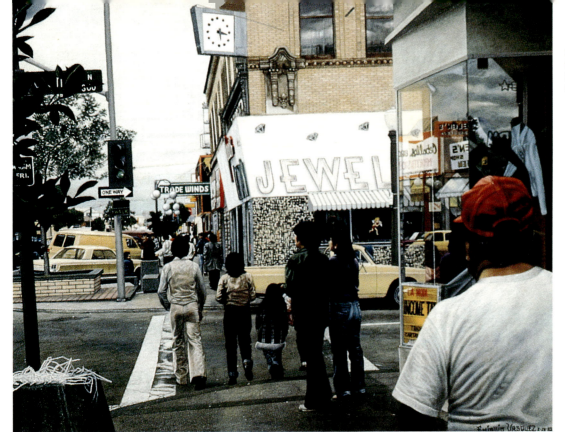

Emigdio Vasquez
Saturday Afternoon on Fourth Street
24" x 30" (61 cm x 76.2 cm)
Canvas

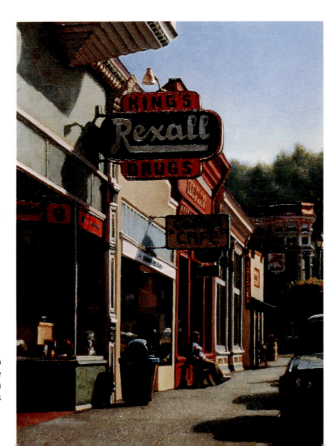

Gretchen H. Warren
Street Scene
14" x 11" (35.6 cm x 27.9 cm)
Canvas

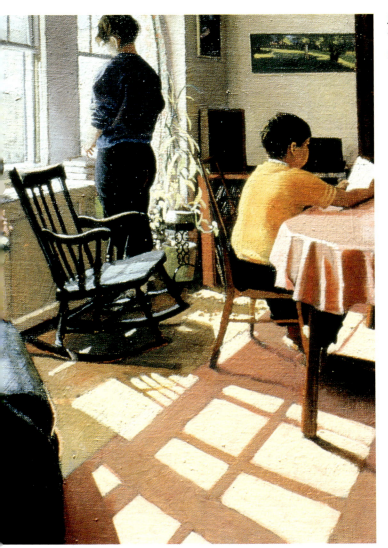

Jim Williams
Mother & Son
18" x 15" (45.7 cm x 38.1 cm)
Linen canvas

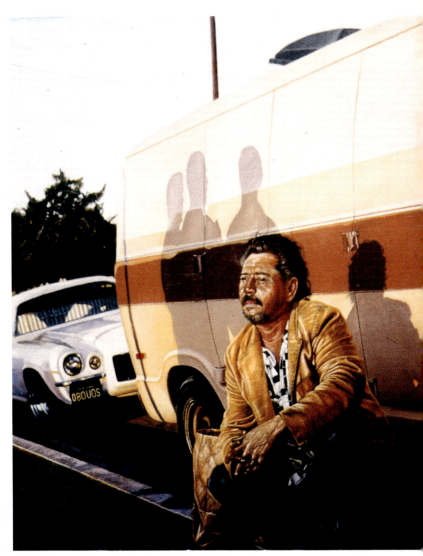

Emigdio Vasquez
John the Prophet
36" x 24" (91.4 cm x 61 cm)
Canvas

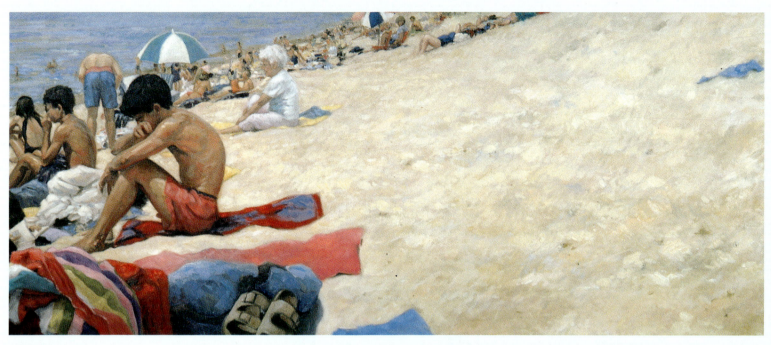

Debra Reid Jenkins
Birks at K.P.
24" x 60" (61 cm x 152.4 cm)
Oil with hide glue and white lead
Canvas

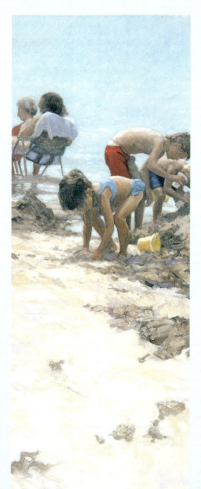

Debra Reid Jenkins
Busy Day
40" x 16" (101.6 cm x 40.6 cm)
Oil with hide glue and white lead
Canvas

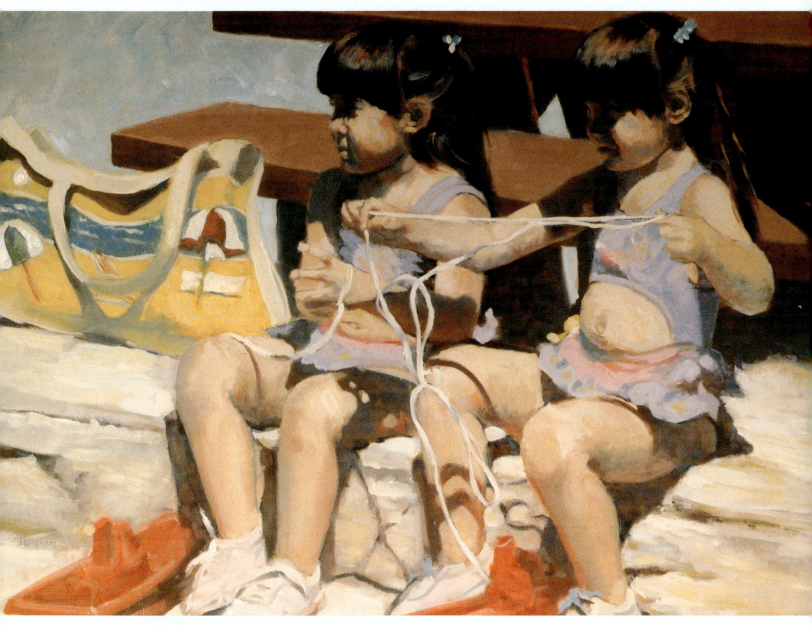

Sandra A. Johnson
Patiently Waiting
30" x 40" (76.2 cm x 101.6 cm)
Gesso-primed watercolor board

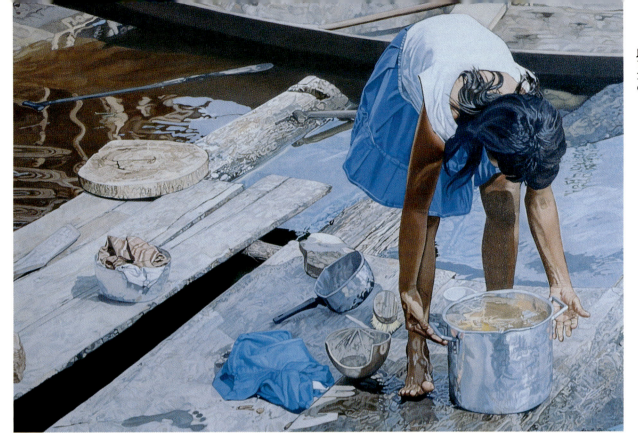

Jeanette Martone
The Water Carrier
25" x 35" (63.5 cm x 88.9 cm)
Canvas

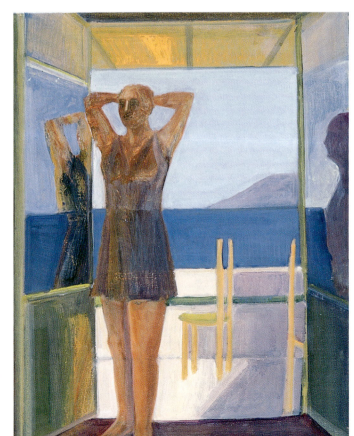

Wendy Gittler
On a Balcony (Aeolian Islands)
20" x 16" (50.8 cm x 40.6 cm)
Canvas

Jeanette Martone
At Bomet
28" x 18" (71.1 cm x 45.7 cm)
Canvas

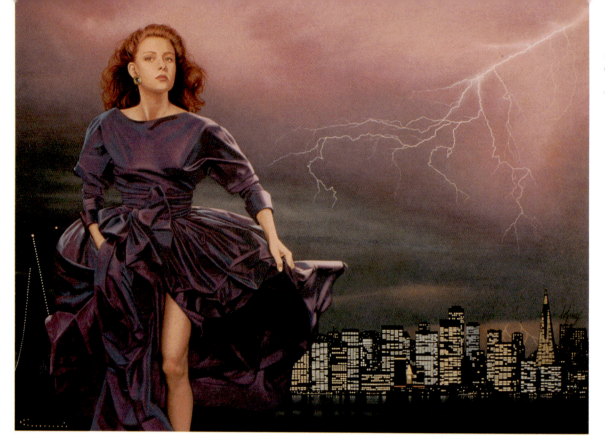

Leslie Maggy-Taylor
Goodbye San Francisco
36" x 48" (91.4 cm x 121.9 cm)
Canvas

Leslie Maggy-Taylor
Evening Star
48" x 24" (121.9 cm x 61 cm)
Canvas

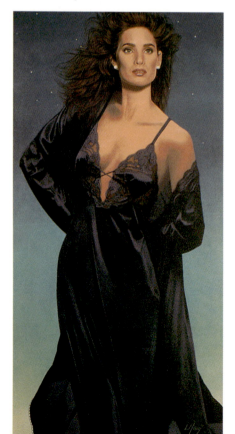

Charlotte Wharton
Beth and Angela Quitadamo (Portrait)
48" x 37" (121.9 cm x 94 cm)
Canvas

Charlotte Wharton
Stacy O.
24" x 20" (61 cm x 50.8 cm)
Canvas

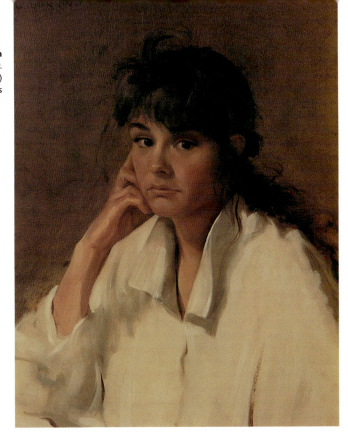

Eileen Kennedy-Dyne
Portrait of Helen Djamspun
28" x 36" (71.1 cm x 91.4 cm)
Oil with grisaille underpainting
Linen

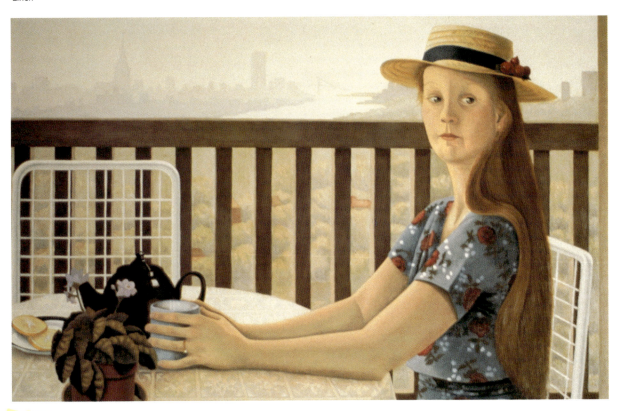

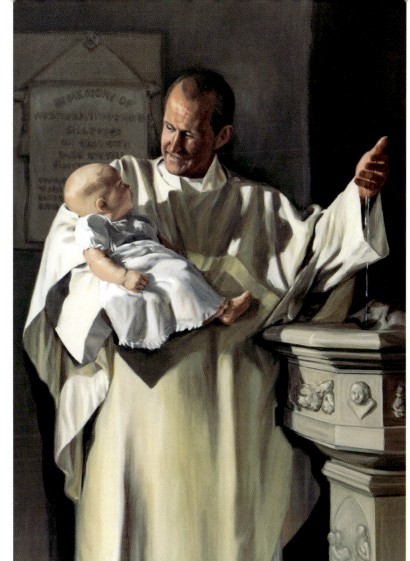

Loryn Brazier
The Baptism
56" x 42" (142.2 cm x 106.7 cm)
Canvas

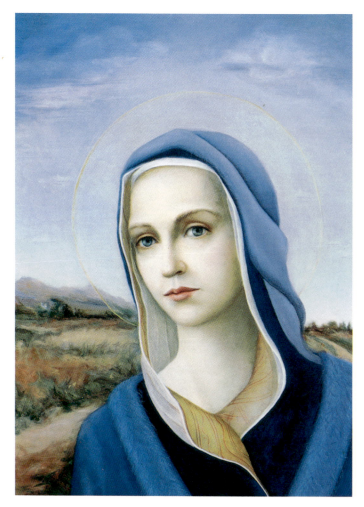

Valori Fussell
Madonna of Medjugorje
18.5" x 13.5" (45 cm x 34.3 cm)
Prepared panel

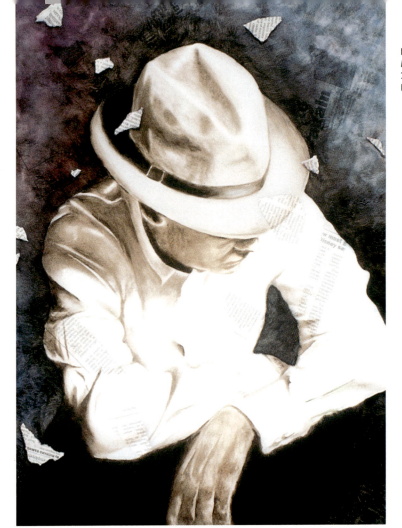

Keith Grace
Ethical Dilemma
24" x 18" (61 cm x 45.7 cm)
Heavy translucent vellum

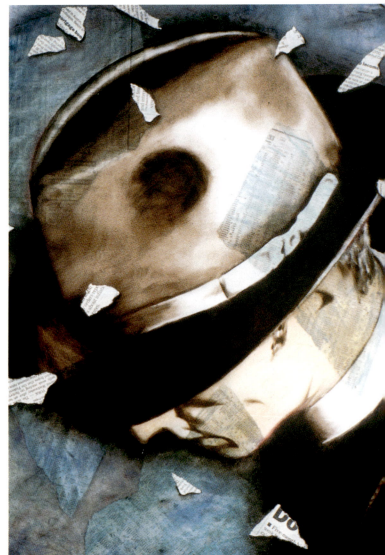

Keith Grace
Final Scoop
24" x 18" (61 cm x 45.7 cm)
Heavy translucent vellum

Dean Mitchell
Been Found
48" x 30" (121.9 cm x 76.2 cm)
Masonite panel

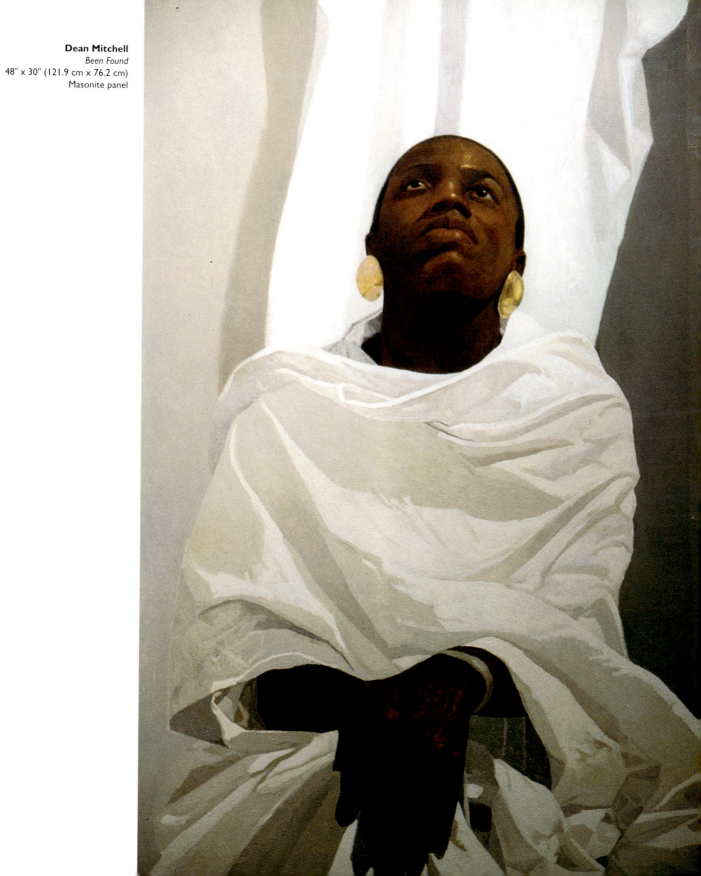

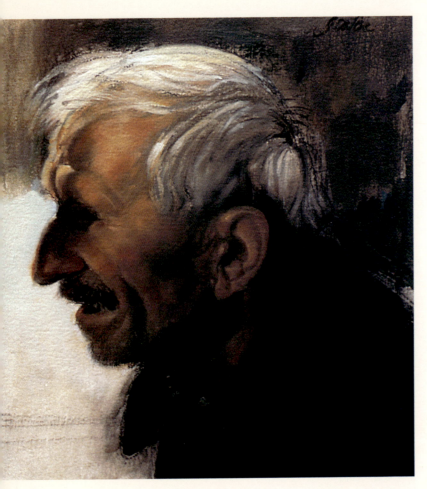

Nick Scalise
Old Man Talking, Profile, Russia
9" x 8.5" (22.2 cm x 21.6 cm)
Illustration board

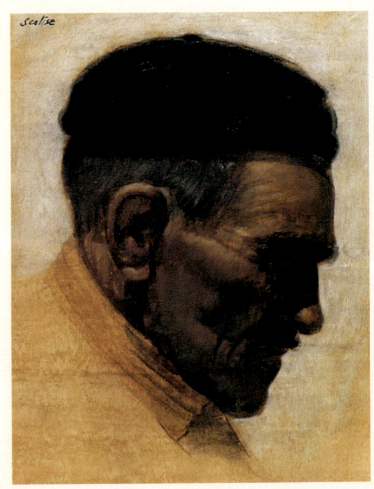

Nick Scalise
Study, Man with Cap, Profile, Italy
9" x 7" (22.9 cm x 17.8 cm)
Illustration board

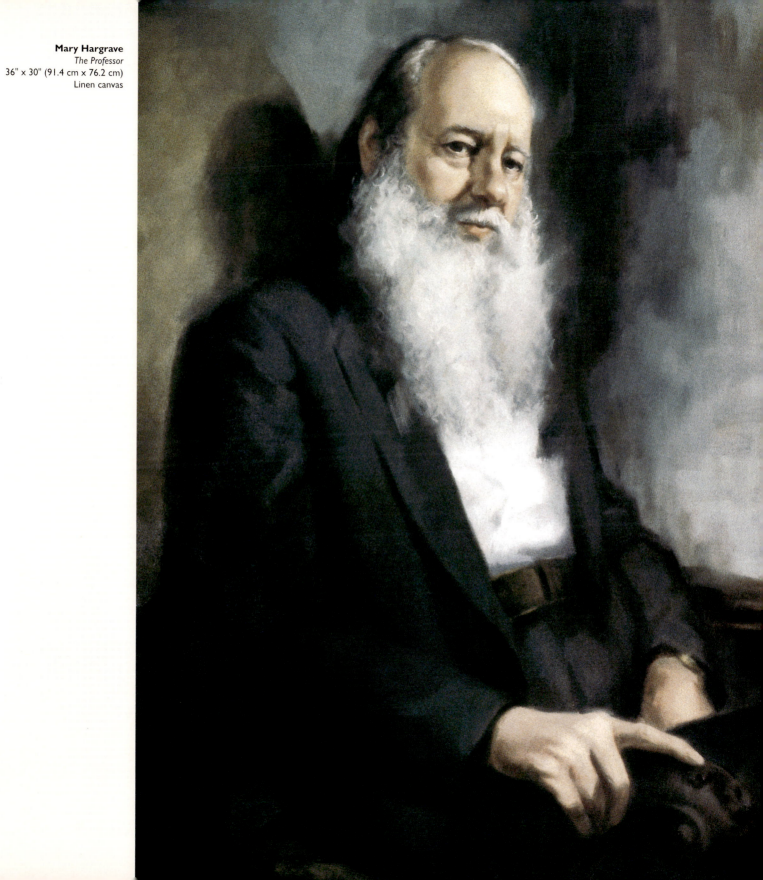

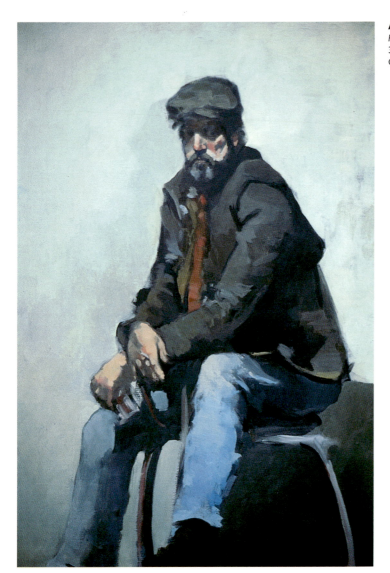

Alexander C. Piccirillo
Ralph Fabricatore
34" x 24" (86.4 cm x 61 cm)
Gesso-primed masonite panel

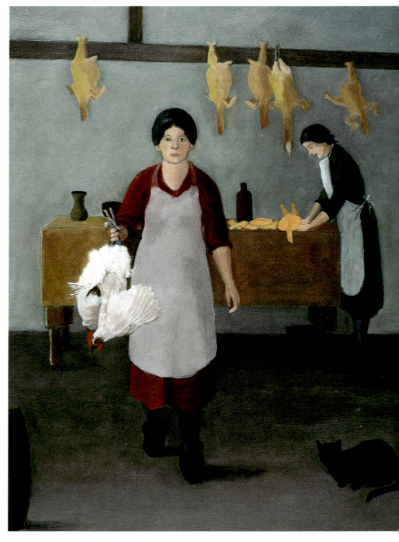

Eva Martino
Chicken House IV
22" x 19" (55.9 cm x 48.3 cm)
Linen canvas

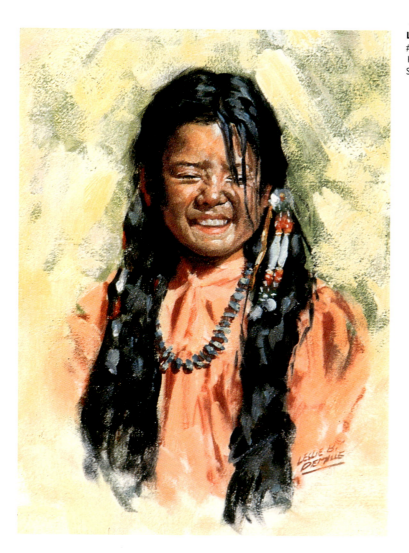

Leslie B. De Mille
#1519 Bright Day
13" x 10" (33 cm x 25.4 cm)
Sennelier pastel cloth

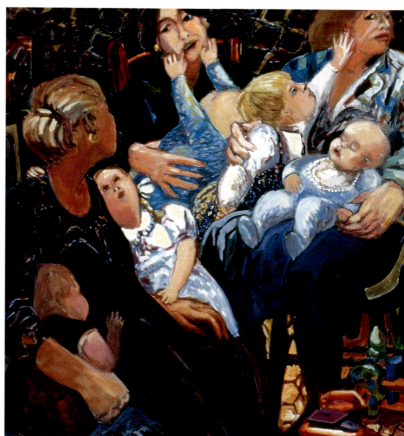

Ann Stewart Anderson
Conversation: Mother Talk
40" x 40" (101.6 cm x 101.6 cm)
Canvas

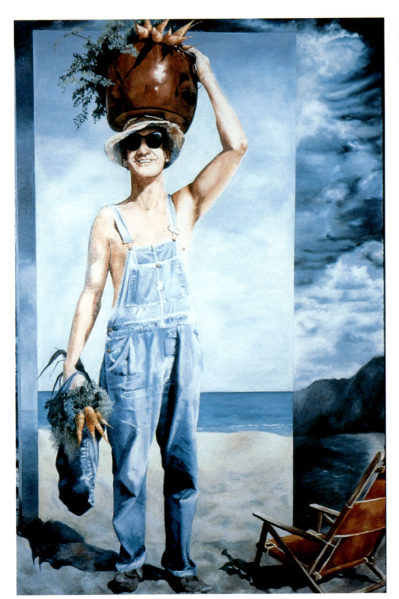

Anne Van Blarcom Kurowski
Maturity
72" x 46" (182.8 cm x 116.8 cm)
Canvas

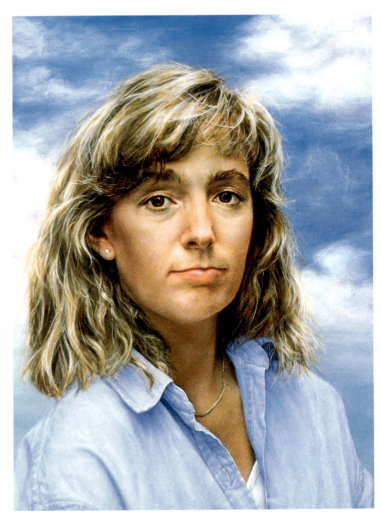

Valori Fussell
Portrait of Marise Stewart
13.3" x 10.3" (33.7 cm x 26 cm)
Prepared Panel

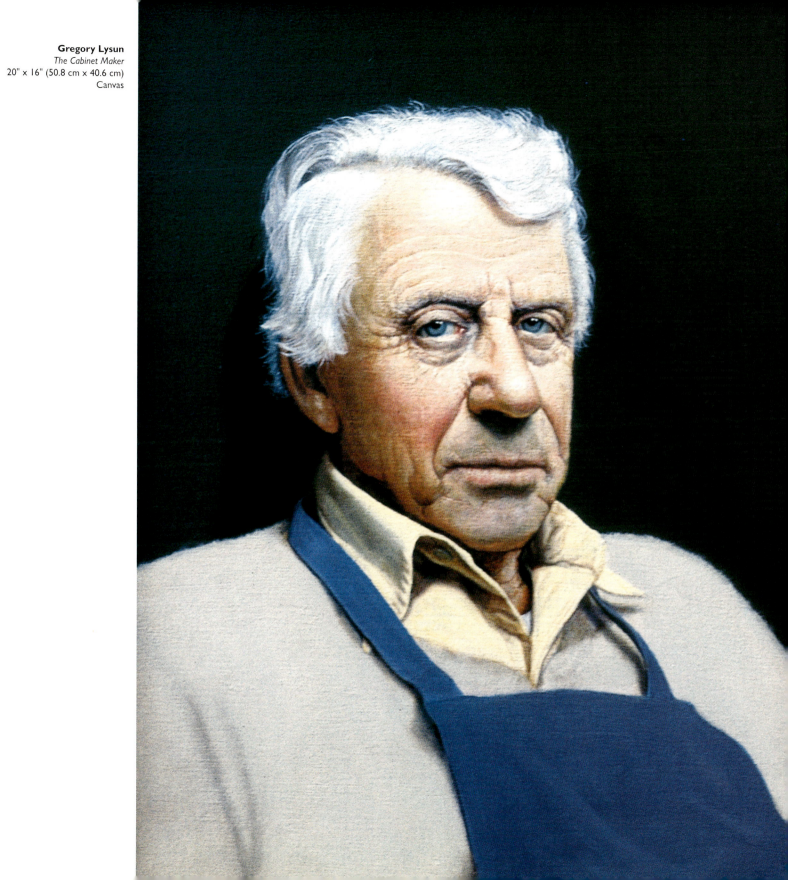

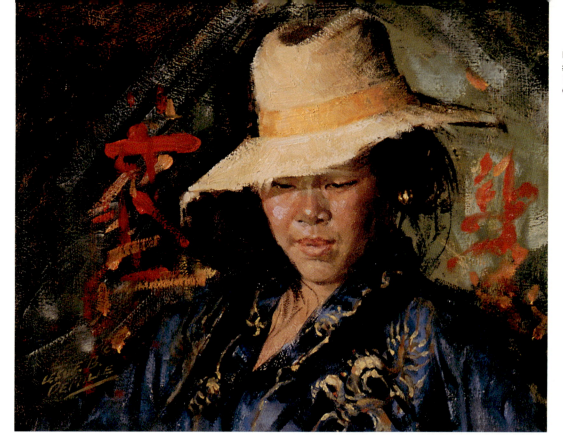

Leslie B. De Mille
#1683 Touch of China
16" x 20" (40.6 cm x 50.8 cm)
Canvas

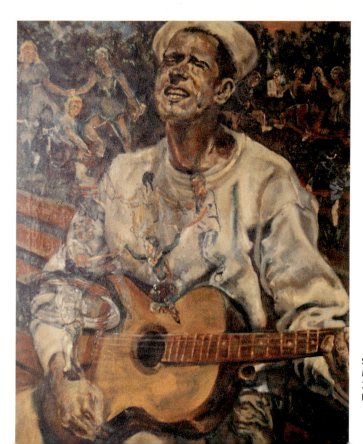

Sidney Findling
Folksinger
31" x 25" (78.7 cm x 63.5 cm)
Primed linen canvas

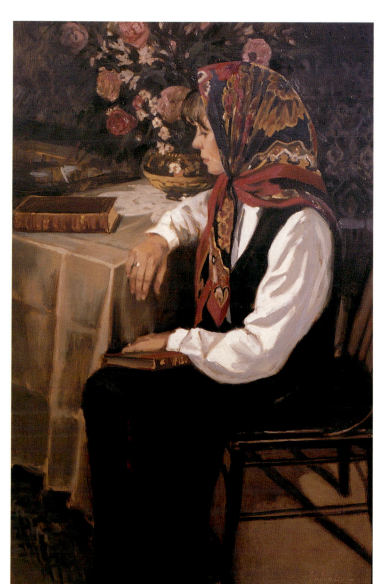

Tony Eubanks
Christina
30" x 20" (76.2 cm x 50.8 cm)
Antwerp linen

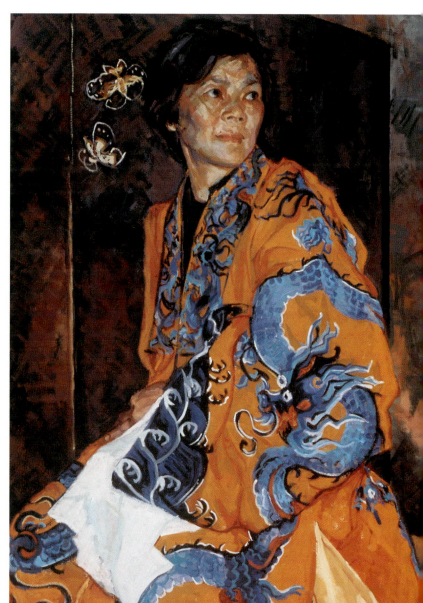

Lucille T. Stillman
Madame Butterfly
48" x 38" (121.9 cm x 96.5 cm)
Linen canvas

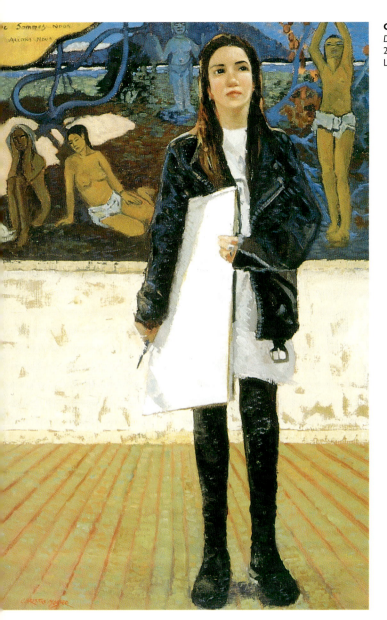

Christine Mosher
Daydream Believer
28" x 22" (71.1 cm x 55.9 cm)
Linen canvas

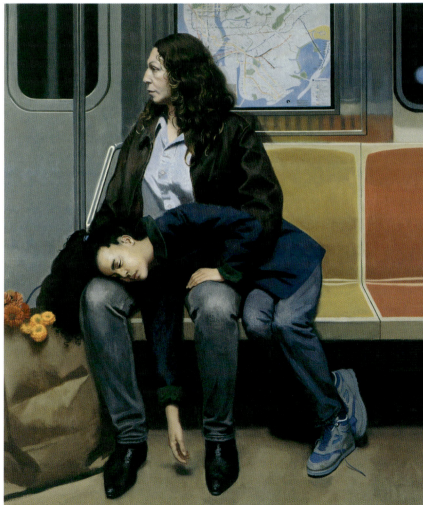

Harvey Dinnerstein
Linda and Alicia
44" x 48.3" (111.8 cm x 122.6 cm)
Canvas

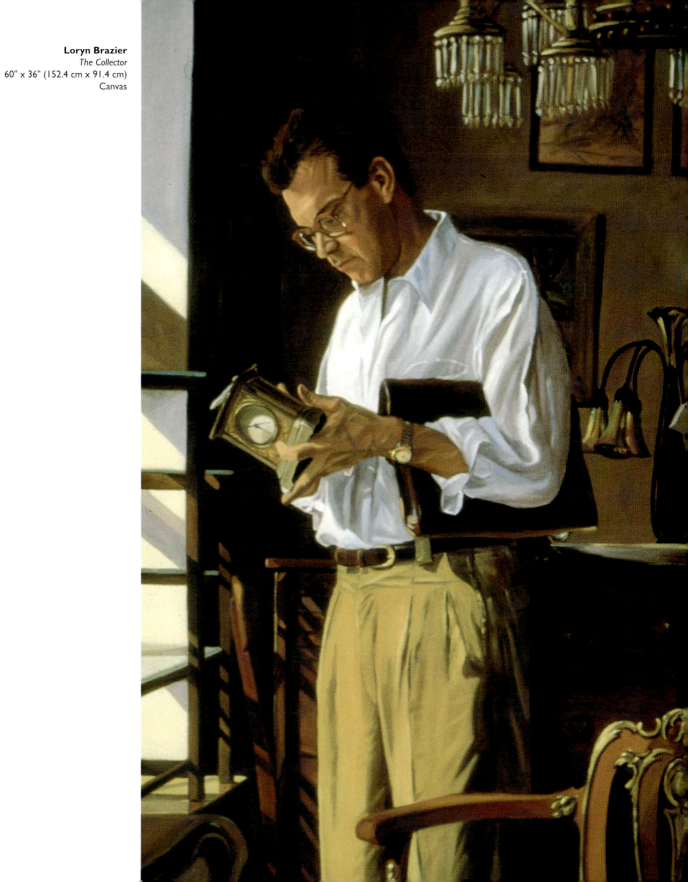

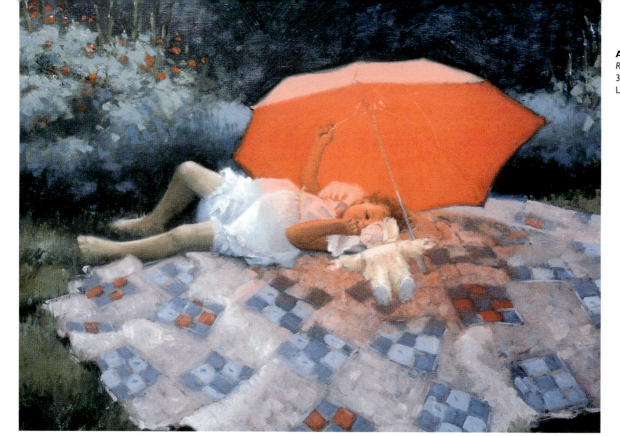

Ann Boyer LePere
Radiant
30" x 36" (76.2 cm x 91.4 cm)
Linen

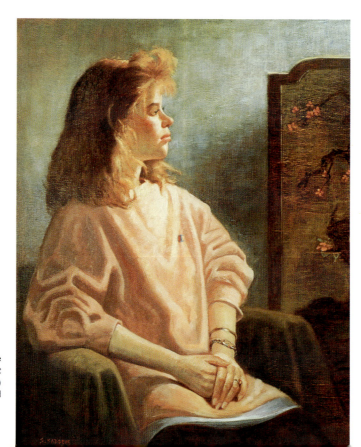

Salomon Kadoche
Portrait
28" x 22" (71.1 cm x 55.9 cm)
Plywood

Mitsuno Ishii Reedy
Easter Hat
24" x 20"
(61 cm x 50.8 cm)
Canvas

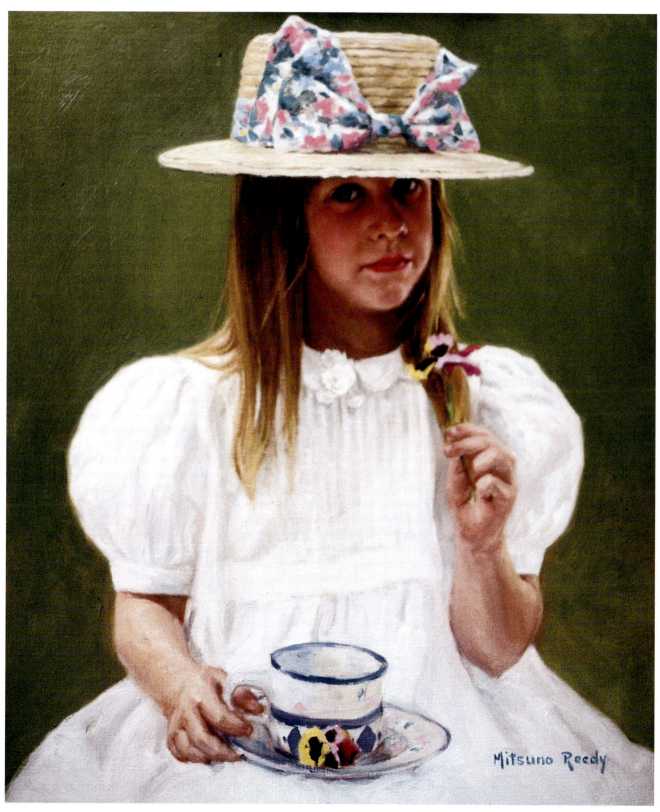

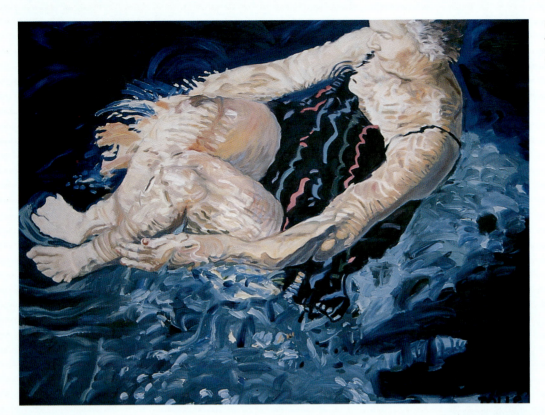

Patricia M. Tolle
Mother's Shadow #4
36" x 48" (91.4 cm x 121.9 cm)
Canvas

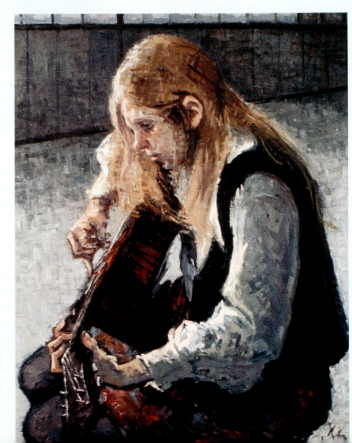

Lucille T. Stillman
The Sociologist
34" x 28" (86.4 cm x 71.1 cm)
Linen canvas

Valori Fussell
Portrait of Kay Ragland
22" x 18.3" (55.9 cm x 46.4 cm)
Canvas

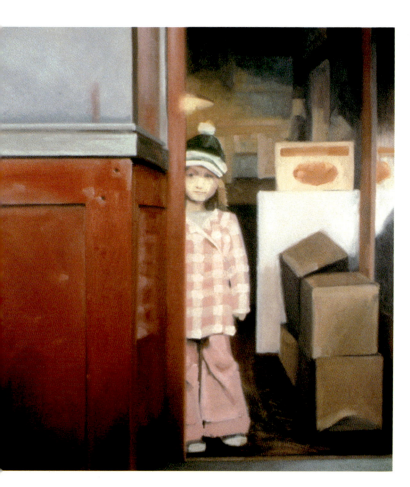

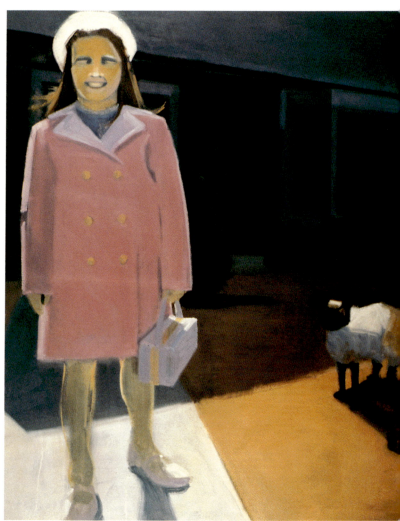

Katherine Reaves
Easter
40" x 36" (101.6 cm x 91.4 cm)
Canvas

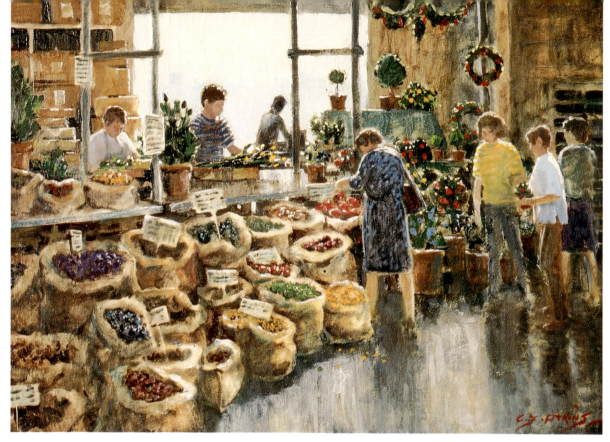

Christine F. Atkins
Dried Flower Market, Brisbane
22" x 31" (55.9 cm x 78.7 cm)
Canvas

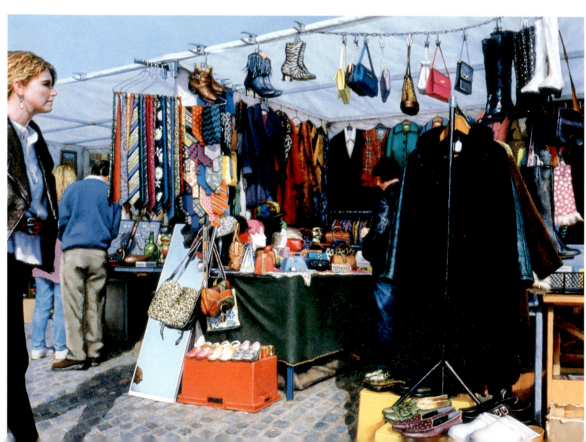

Gretchen H. Warren
Sunday Shopping
30" x 40" (76.2 cm x 101.6 cm)
Canvas

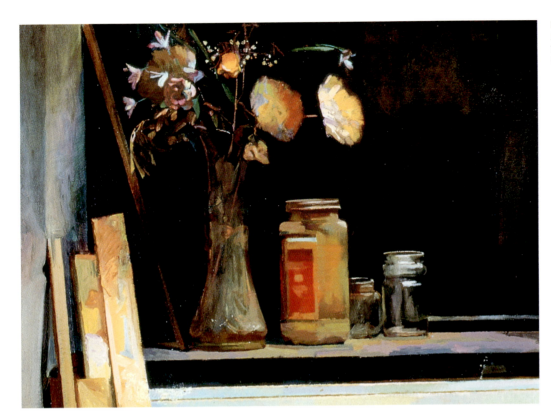

Periklis Pagratis
Still Life
22" x 28" (55.9 cm x 71.1 cm)
Canvas

Kristi Krafft
After a Hard Day's Work
18" x 36" (45.7 cm x 91.4 cm)
Cardboard

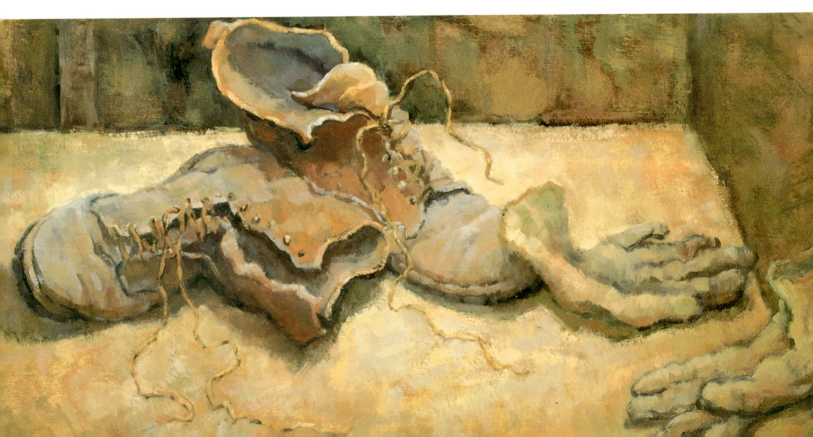

Joyce Williams
Collection
20" x 24" (50.8 cm x 61 cm)
Canvas

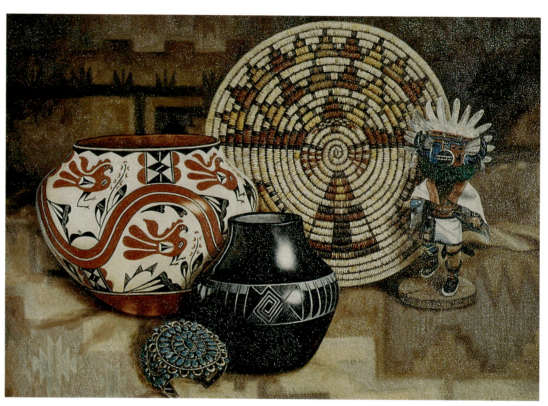

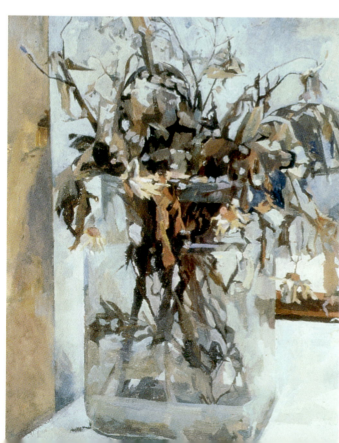

Periklis Pagratis
Still Life
22" x 18" (55.9 cm x 45.7 cm)
Canvas

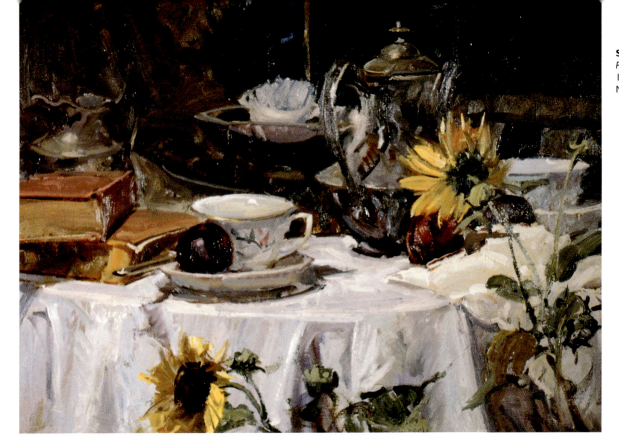

Suzanne Shedosky
Plums
18" x 24" (45.7 cm x 61 cm)
Masonite panel

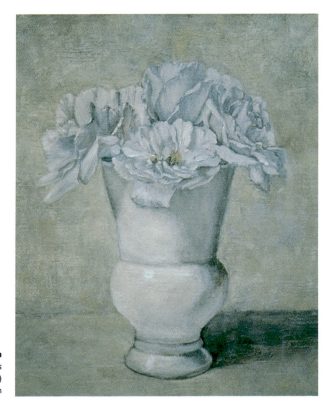

Elsie Eastman
Pale Roses
12" x 10" (30.5 cm x 25.4 cm)
Lead-primed linen

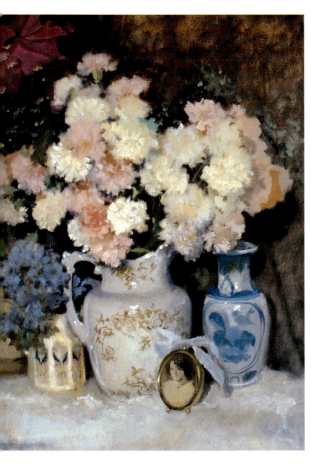

Roberta Carter Clark
Pink Carnations
32" x 27" (81.2 cm x 68.6 cm)
Linen canvas

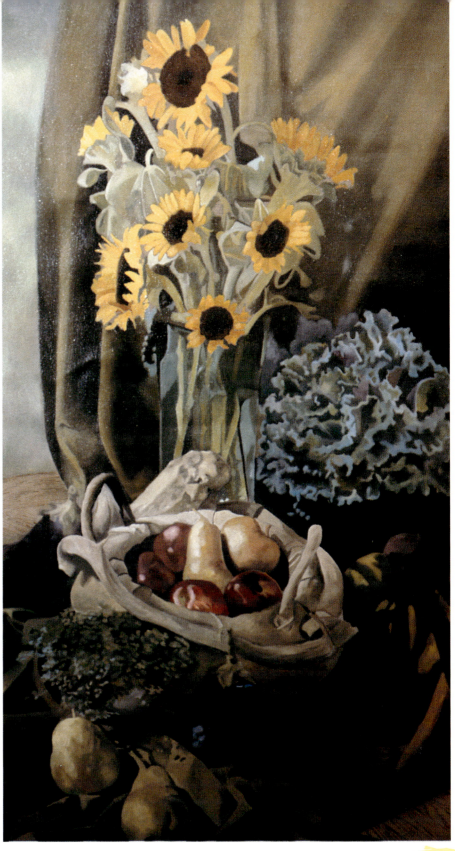

Kathryn S. Heuzey
Kitchen Landscape Sunflowers
36" x 23" (91.4 cm x 58.4 cm)
Canvas

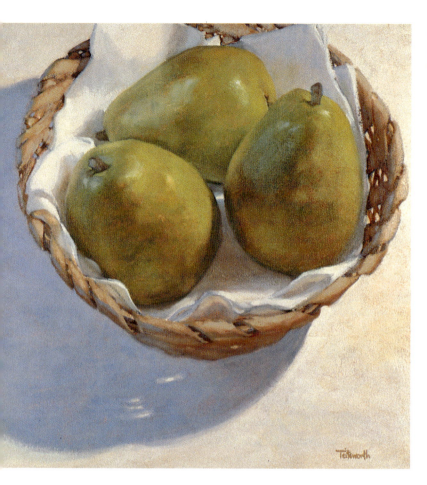

Bill Teitsworth
Three Pears
24" x 24" (61 cm x 61 cm)
Utrecht CD 10 Canvas

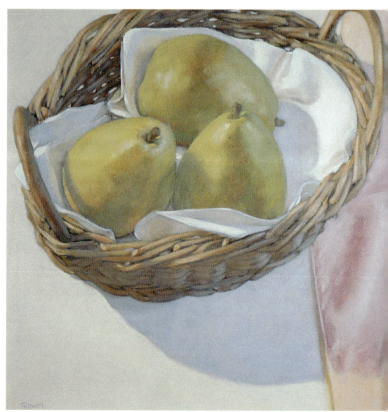

Bill Teitsworth
Pears
28" x 24" (71.1 cm x 61 cm)
Utrecht CD 10 Canvas

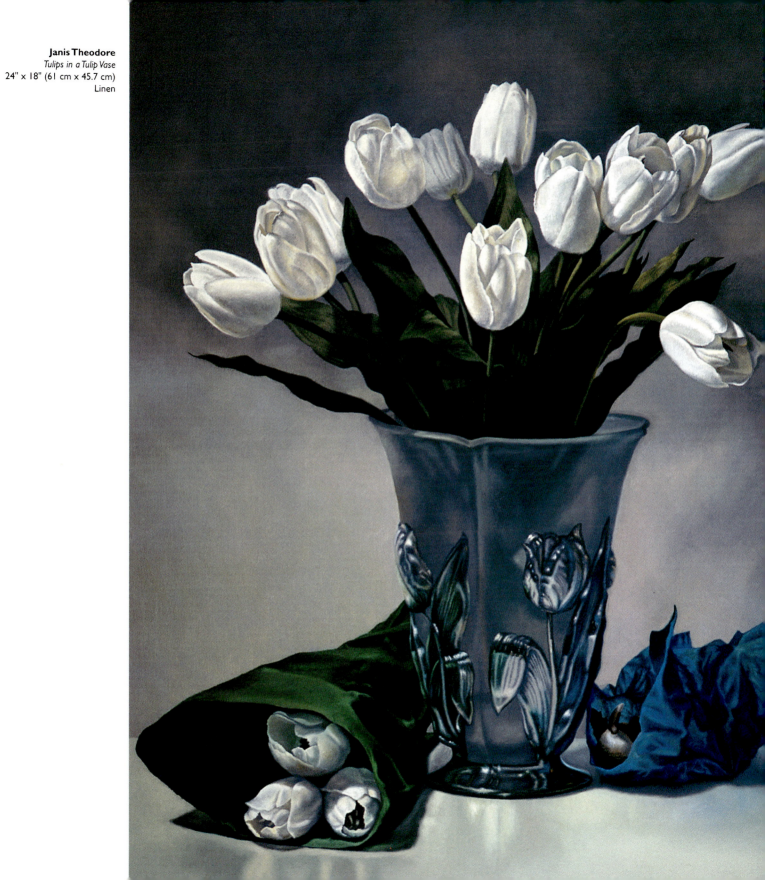

Janis Theodore
Tulips in a Tulip Vase
24" x 18" (61 cm x 45.7 cm)
Linen

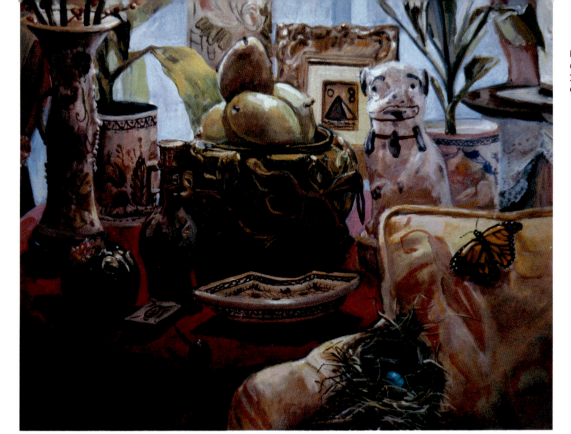

F. Sinsabaugh
Changes
24" x 30" (61 cm x 76.2 cm)
Canvas

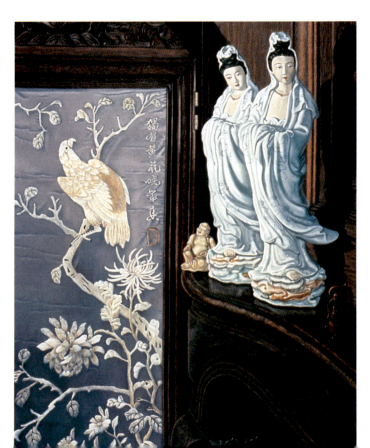

Janis Theodore
Autumn Blossom
30" x 24" (76.2 cm x 61 cm)
Linen

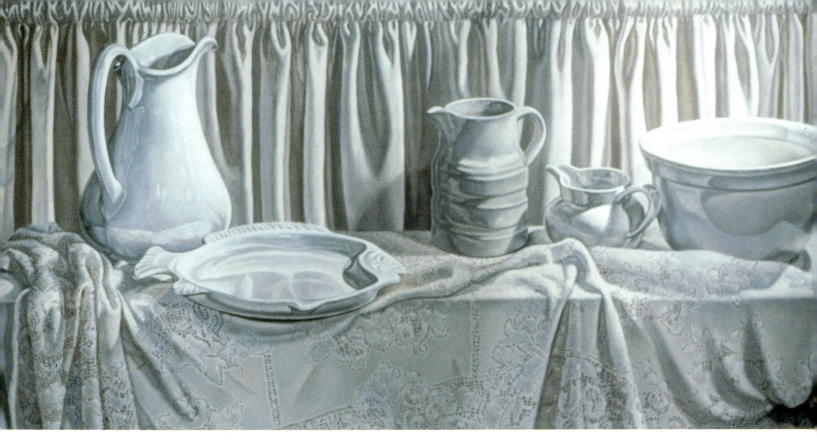

Janis Theodore
Grisaille Tablecloth with Fish Dish
20" x 40" (50.8 cm x 101.6 cm)
Canvas

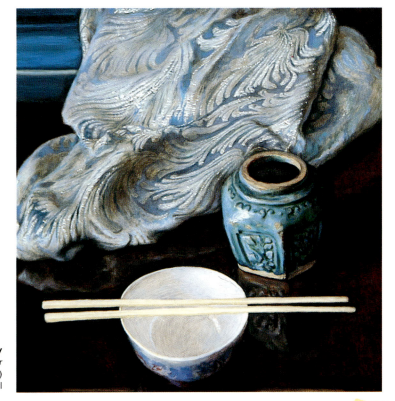

David Hardy
A Taste of Ginger
12" x 12" (30.5 cm x 30.5 cm)
Gesso-primed panel

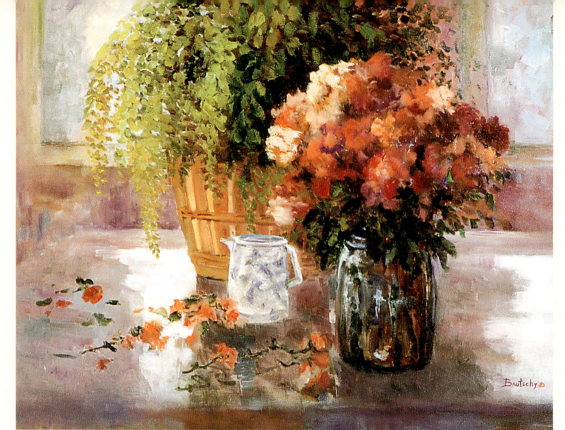

Gerri Brutschy
Still Life with Fern
20" x 24" (50.8 cm x 61 cm)
Stretched canvas

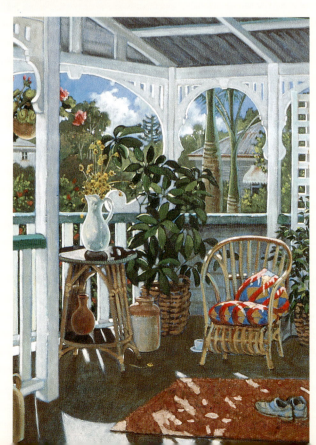

Christine F. Atkins
Tropical Verandah
31" x 22" (78.7 cm x 55.9 cm)
Canvas

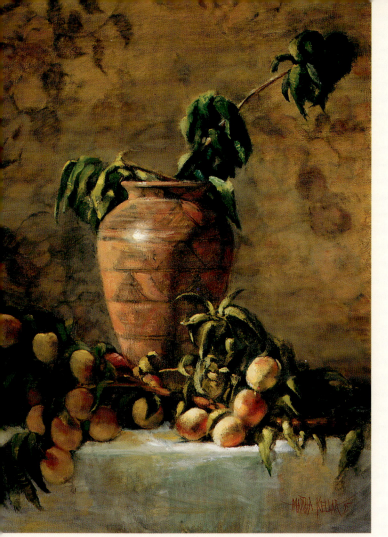

Martha Kellar
Peach Branch with Vase
30" x 24" (76.2 cm x 61 cm)
Canvas

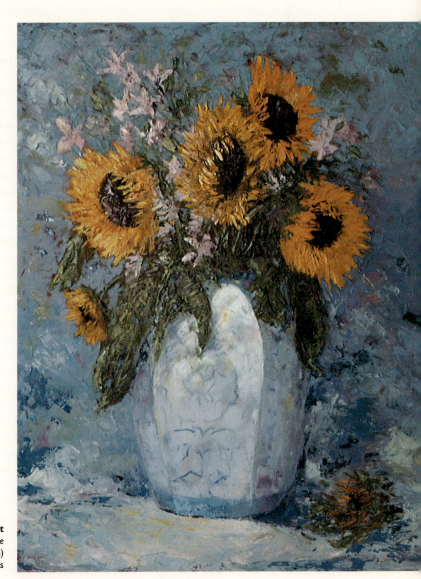

Urania Christy Tarbet
Sunflowers and Blue
30" x 24" (76.2 cm x 61 cm)
Canvas

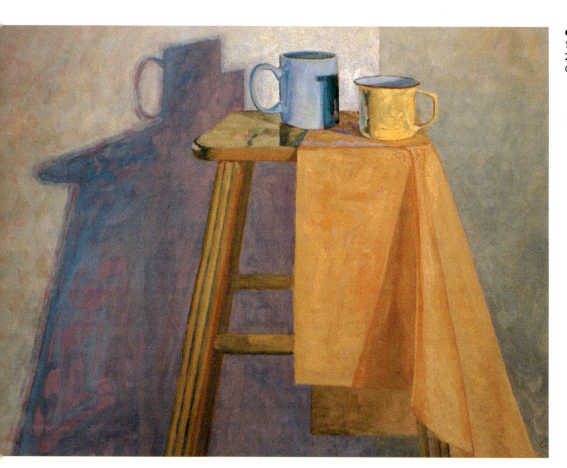

Georgiana Cray Bart
Yellow Mug with Blue Mug on Yellow Bench
24" x 32" (61 cm x 81.3 cm)
Canvas

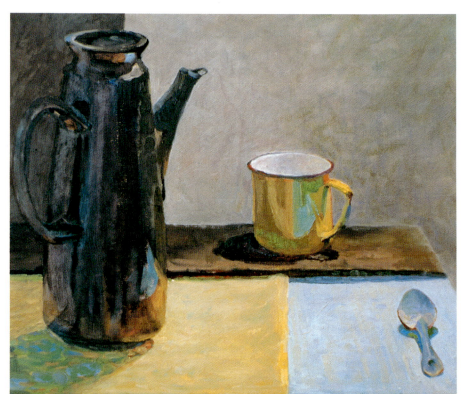

Georgiana Cray Bart
Yellow Mug with Coffee Pot #1
14" x 16" (35.6 cm x 40.6 cm)
Canvas

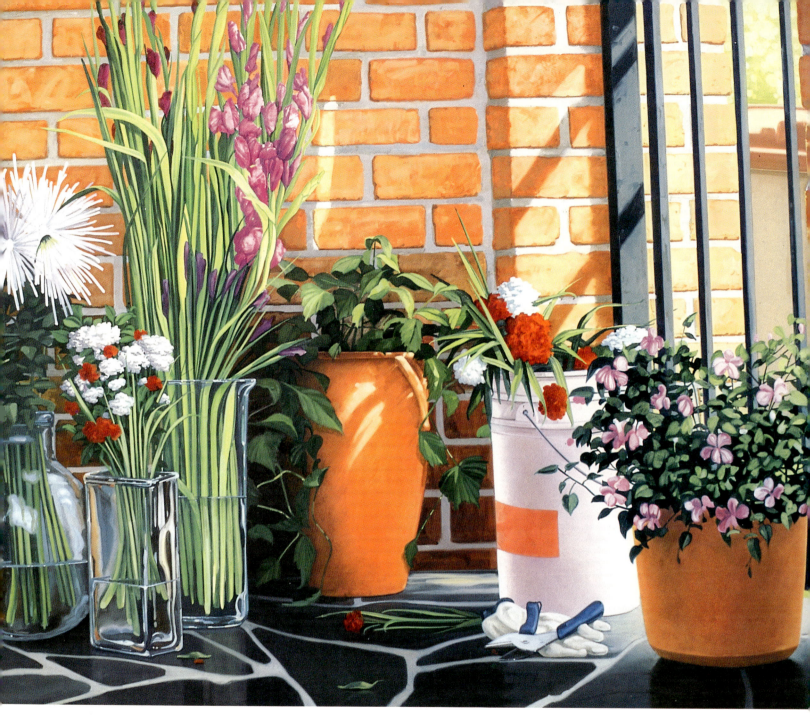

Gregory Johnson
Patio Reflections
35" x 45" (88.9 cm x 114.3 cm)
Ultrasmooth cotton duck

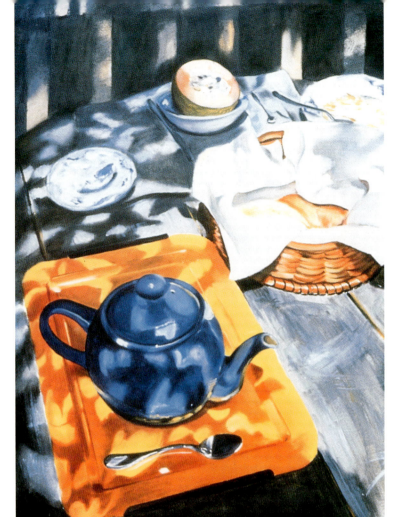

Judith Futral Evans
Breakfast Triptych (Detail)
60" x 132" (152.4 cm x 335.3 cm)
Canvas

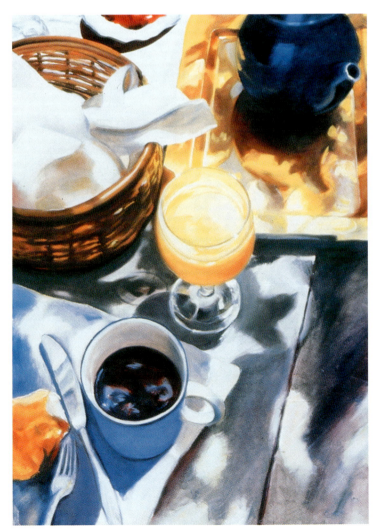

Judith Futral Evans
Breakfast Triptych (Detail)
60" x 132" (152.4 cm x 335.3 cm)
Canvas

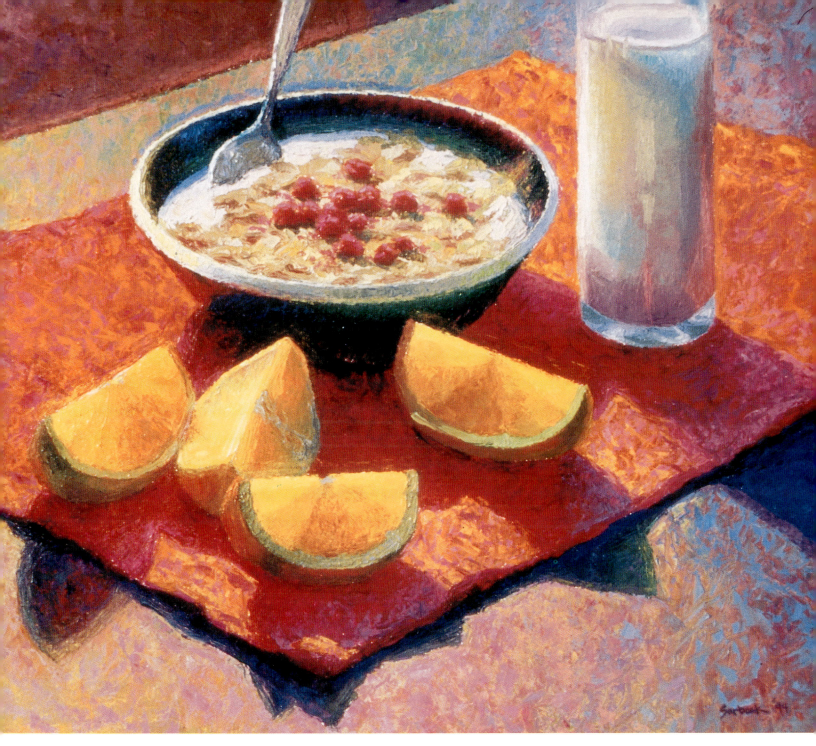

Susan Sarback
Breakfast
20" x 24" (50.8 cm x 61 cm)
Masonite board

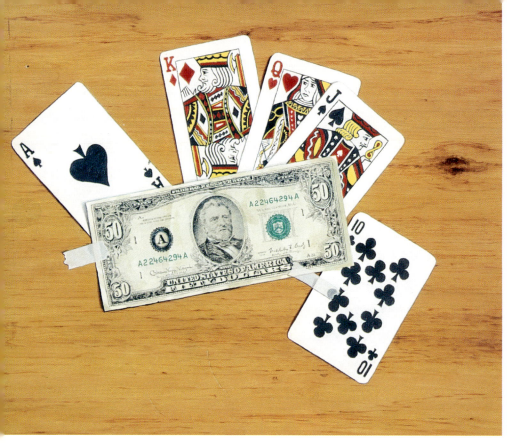

Reid Christman
Fifty Dollar Flush
12" x 16" (30.5 cm x 40.6 cm)
Masonite panel

Mary Close
Lick
10" x 8" (25.4 cm x 20.3 cm)
Canvas

Kevin M. Donahue
Obsession
36" x 48" (91.4 cm x 121.9 cm)
Oil-primed linen canvas

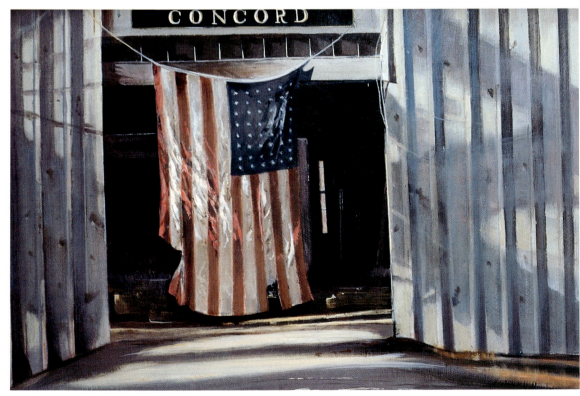

Fred MacNeill
April 19th
24" x 36" (61 cm x 91.4 cm)
Oil with turpentine and varnish
Masonite board

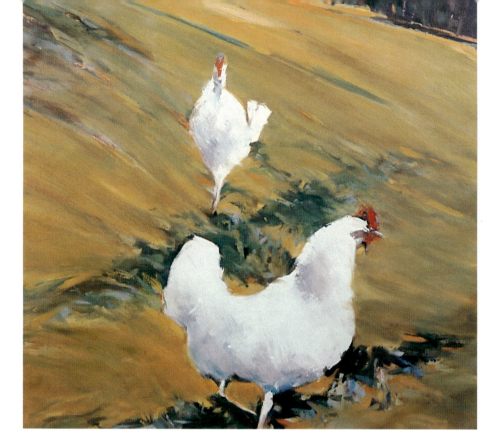

Jann T. Bass
Chichen
30" x 30" (76.2 cm x 76.2 cm)
Gesso-primed canvas

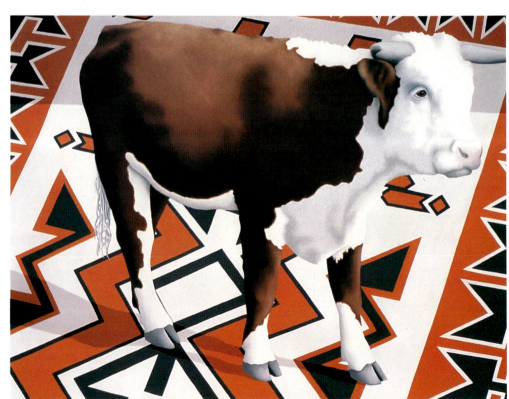

Sharon Di Giacinto
Look What They've Done to My Cow, Ma
36" x 48" (91.4 cm x 121.9 cm)
Canvas

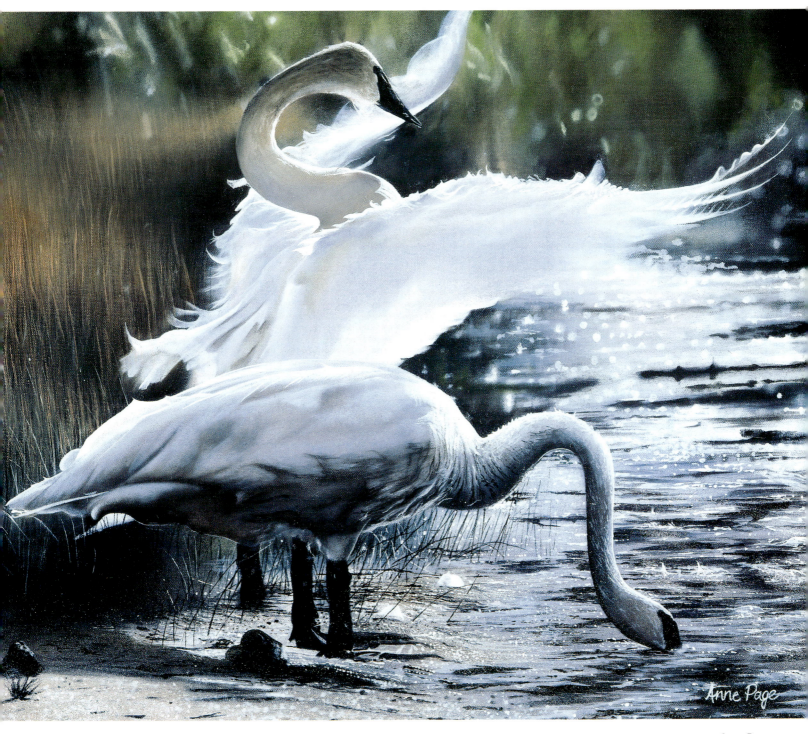

Anne Page
Trumpeter Swans
16" x 20" (40.6 cm x 50.8 cm)
Canvas

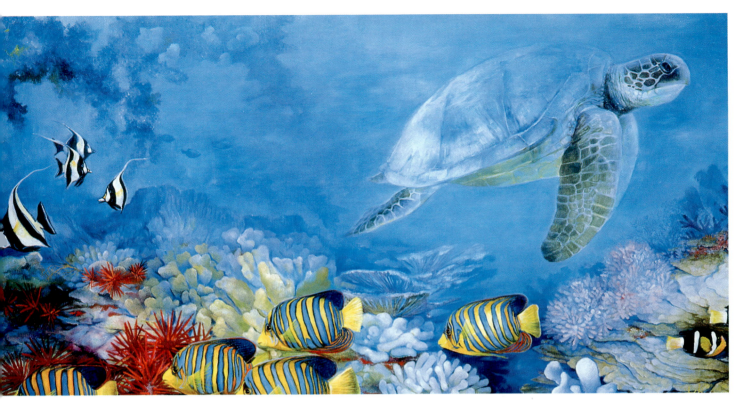

Beti Kristof
Underwater Ways
22" x 40" (55.9 cm x 101.6 cm)
Canvas

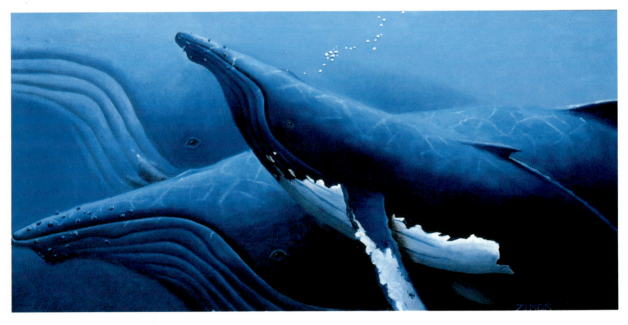

Zimos
Untitled
9" x 18" (22.9 cm x 45.7 cm)
Masonite

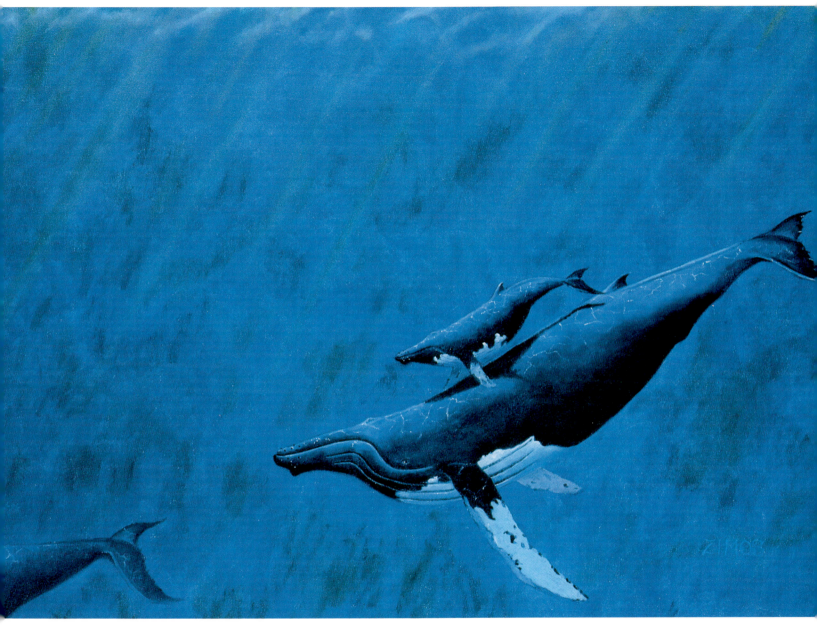

Zimos
Migrating Giants
24" x 36" (61 cm x 91.4 cm)
Canvas

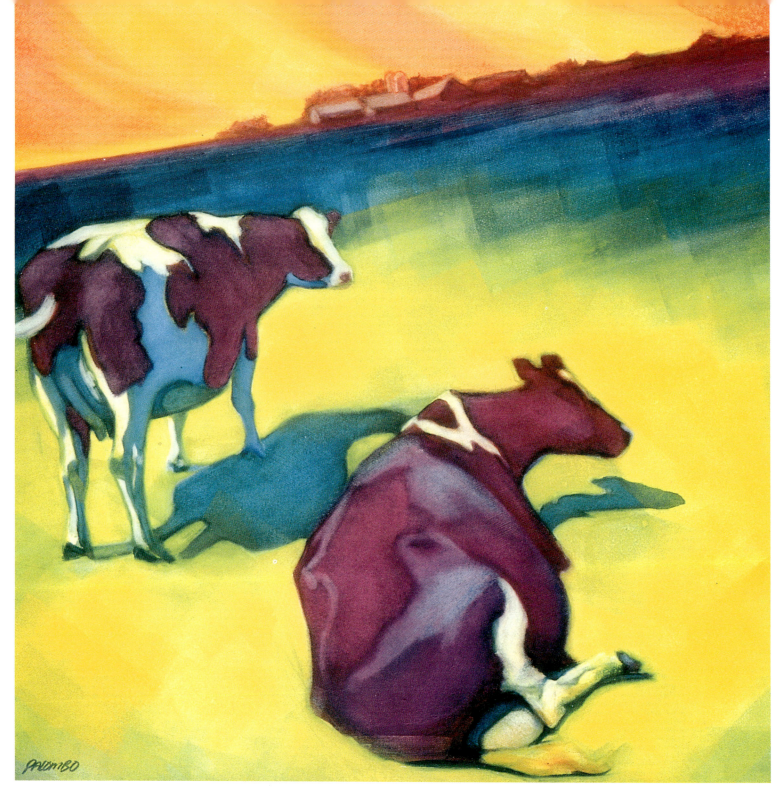

Lisa Palombo
Nuclear Cows
16" x 16" (40.6 cm x 40.6 cm)
Gesso-primed paper

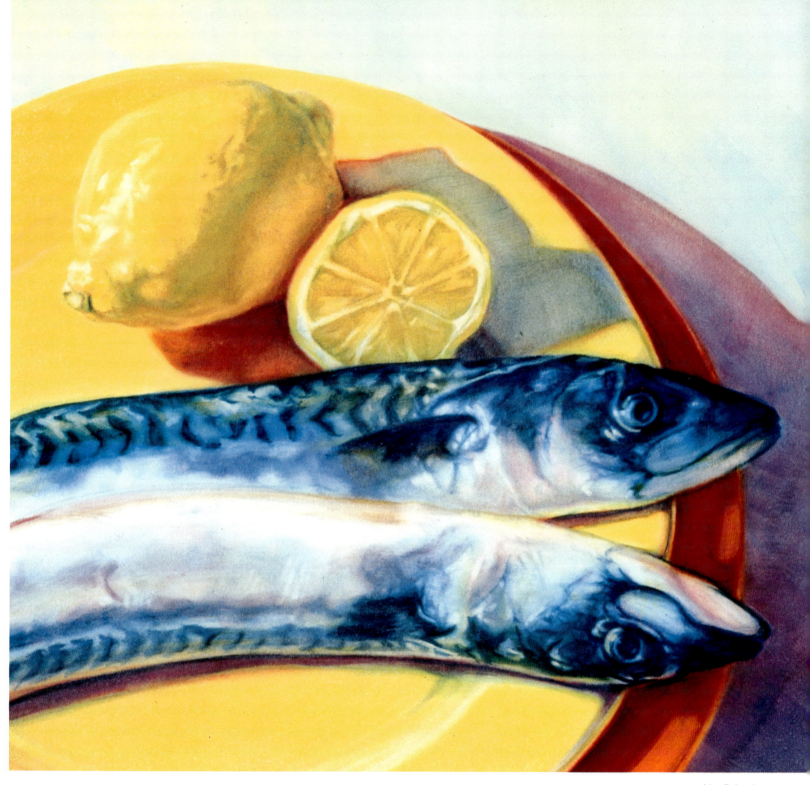

Lisa Palombo
Two Fish
12" x 13" (30.5 cm x 33 cm)
Gesso-primed paper

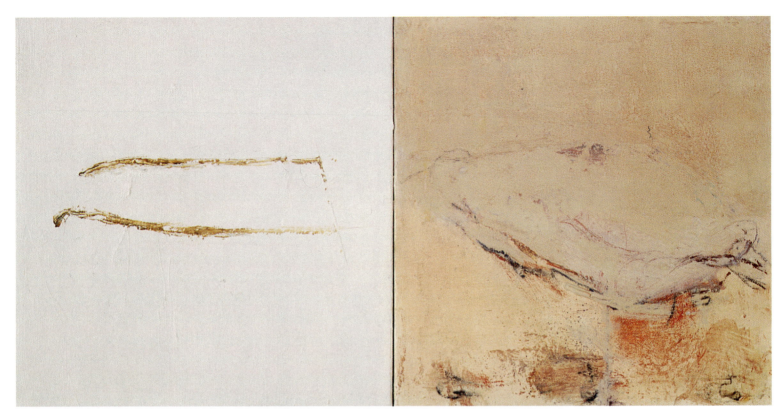

Kerri McLaughlin
The Tissue of Hearts
12" x 24" (30.5 cm x 61 cm)
Canvas

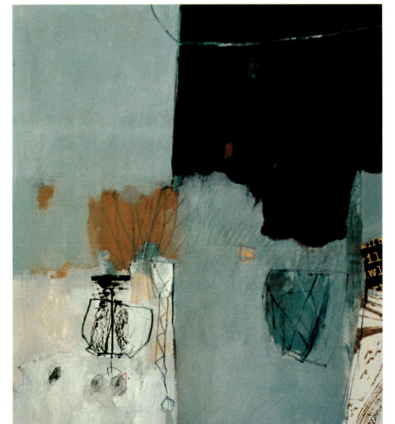

Katherine Chang Liu
Magic Carpet
17" x 17" (43.2 cm x 43.2 cm)
300 lb. Hot press paper
Oil with gesso

David Van DenBerg
Dionysos
40" x 30" (101.6 cm x 76.2 cm)
Canvas

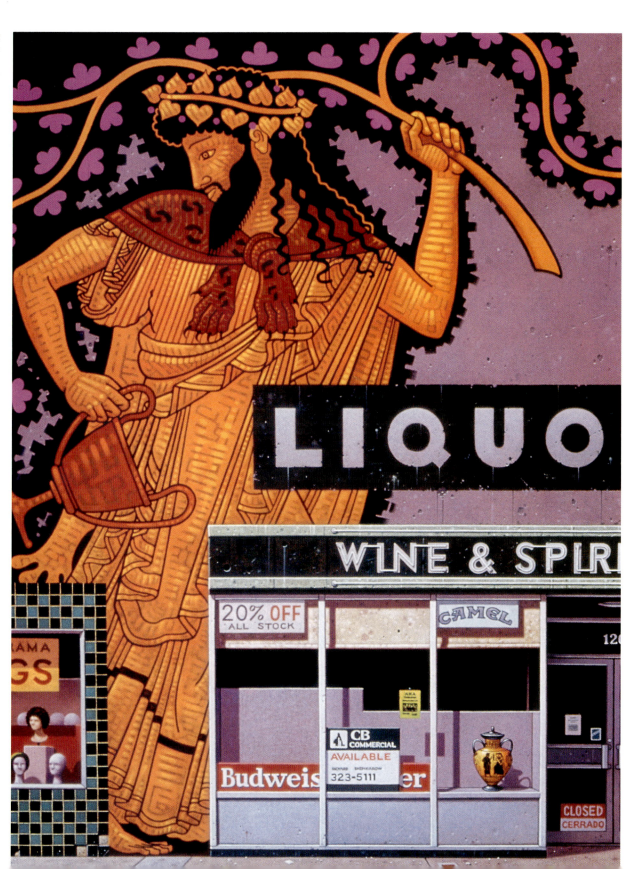

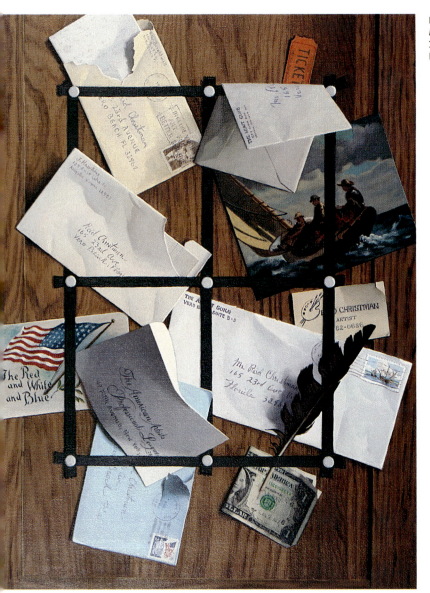

Reid Christman
Letters and Postcards
24" x 18" (61 cm x 45.7 cm)
Fredrix linen canvas

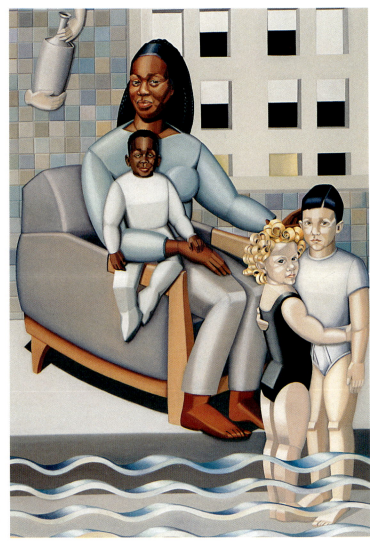

Armanda Balsamo
American Diva
40" x 28" (101.6 cm x 71.1 cm)
Canvas

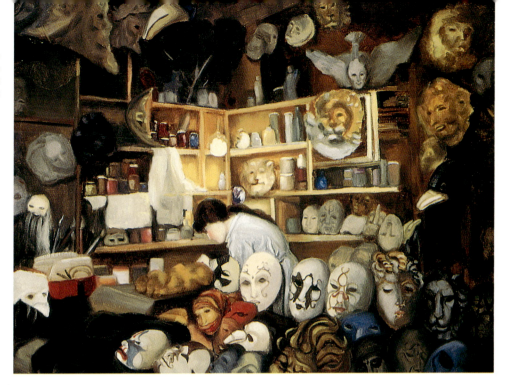

Joanna Calabro
Mask Maker, Venice
24" x 36" (61 cm x 76.2 cm)
Linen canvas

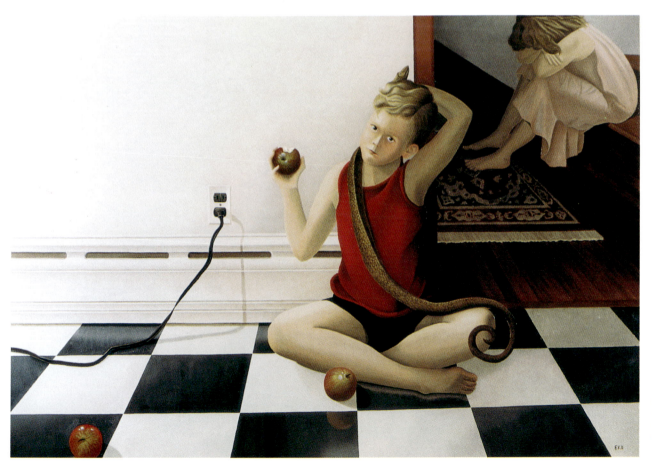

Eileen Kennedy-Dyne
Snakes and Ladders
48" x 68"
(121.9 cm x 172.7 cm)
Canvas

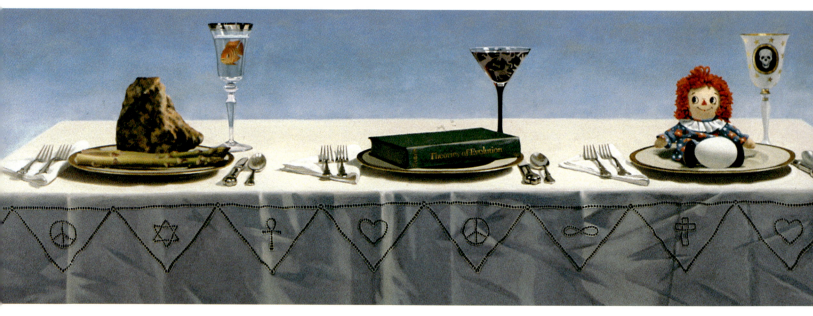

Mary Close
Heaven and Earth
20" x 60"
(50.8 cm x 152.4 cm)
Linen

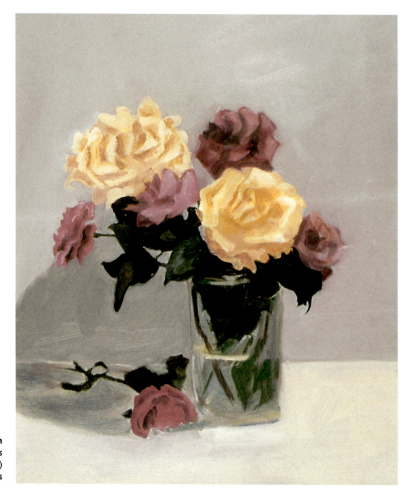

Toby Goldman
Roses
20" x 16" (50.8 cm x 40.6 cm)
Canvas

Beti Kristof
Midsummer's Eve
52" x 22" (132 cm x 55.9 cm)
Canvas

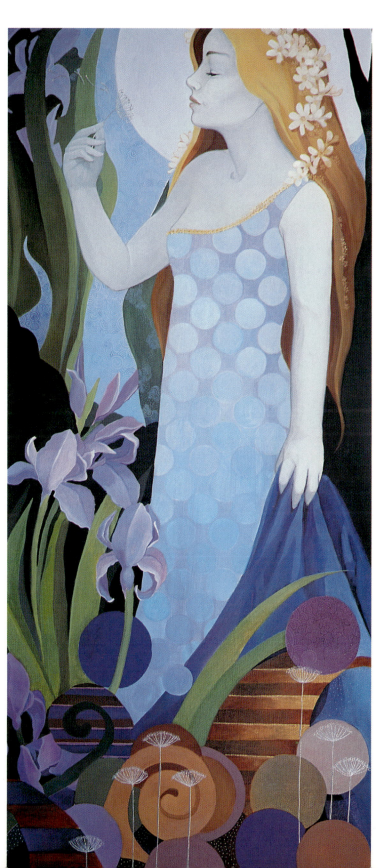

Winston Hough
Late Evening
34" x 44" (86.4 cm x 111.8 cm)
Canvas

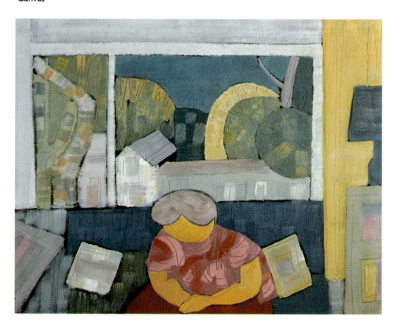

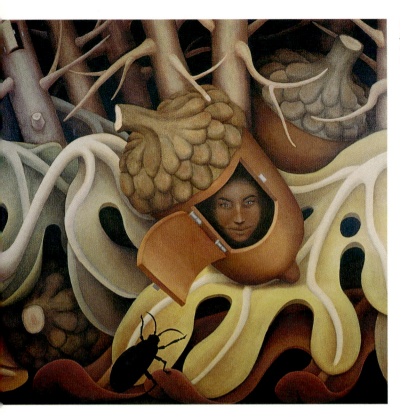

Carole C. Quam
Another Point of View
42" x 46" (106.7 cm x 116.8 cm)
Canvas

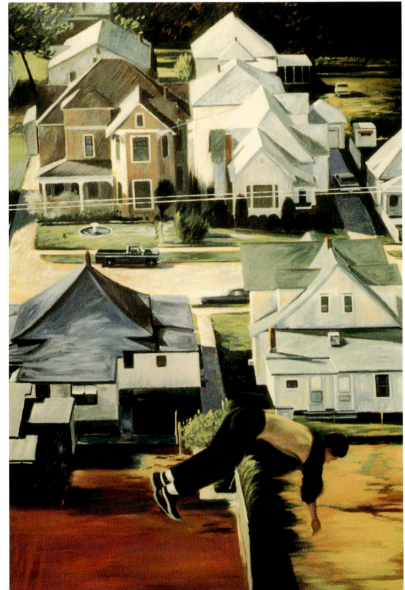

George Oswalt
Baghdad, Oklahoma
72" x 60" (182.9 cm x 152.4 cm)
Canvas

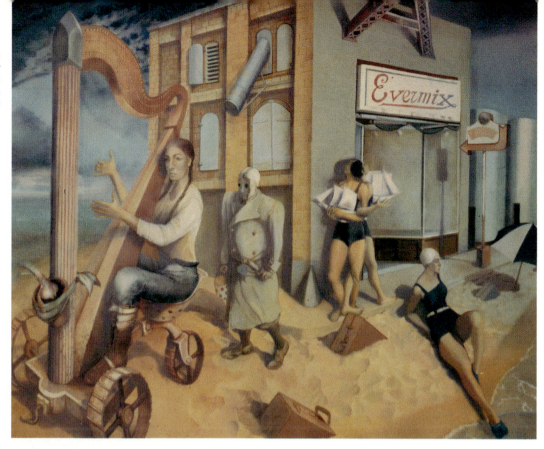

Henryk Fantazos
Misrememberances of Summer
40" x 50" (101.6 cm x 127 cm)
Oil with egg tempera
Canvas

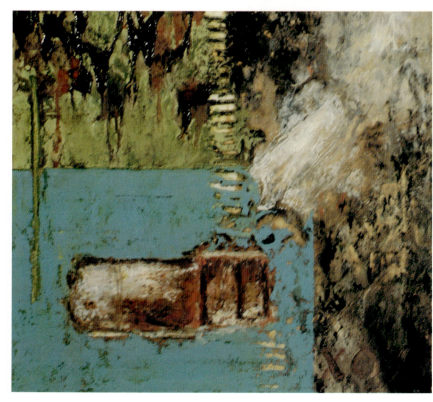

Steve Powers
The Zipper (Varick St.)
20" x 22" (50.8 cm x 55.9 cm)
Canvas

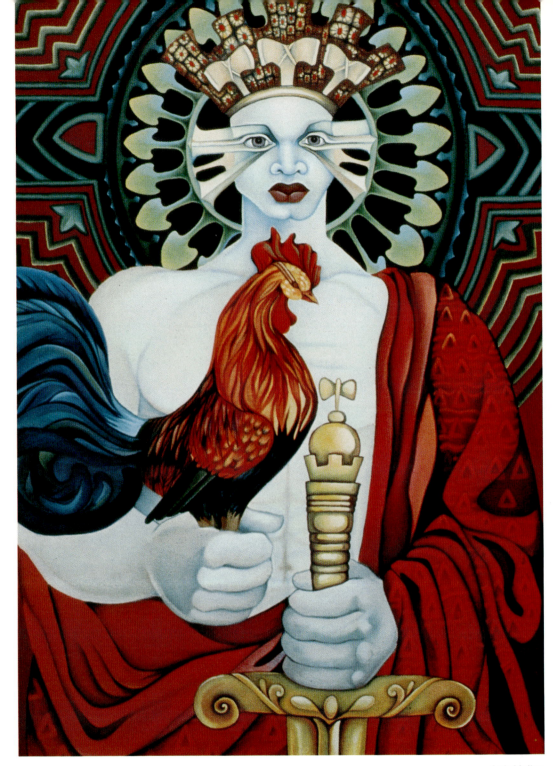

Tod W. Fassbender
Sacred Tapestry of Life
48" x 12" (121.9 cm x 30.5 cm)
Plywood

Luis Molina
Chango
39" x 29" (99.1 cm x 73.7 cm)
Canvas

Rene Hinds
Methods of Modern Love I
12" x 9" (30.5 cm x 22.9 cm)
Oil with pastel and graphic tape
Canvas

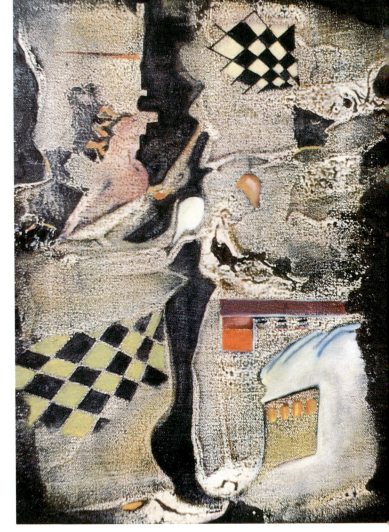

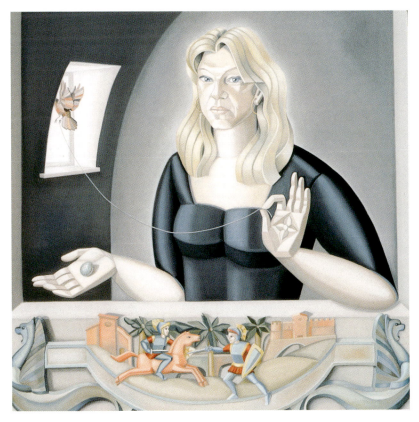

Armanda Balsamo
My Reward Thy Love Shall Be-#1
24" x 24" (61 cm x 61 cm)
Canvas

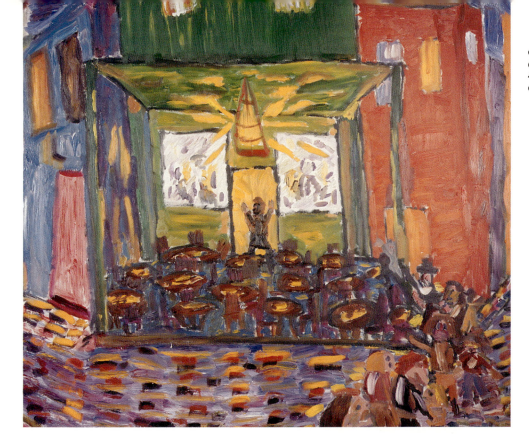

Chip Myers
Opening of the Cafe of Ill Repute
48" x 60" (121.9 cm x 152.4 cm)
Canvas

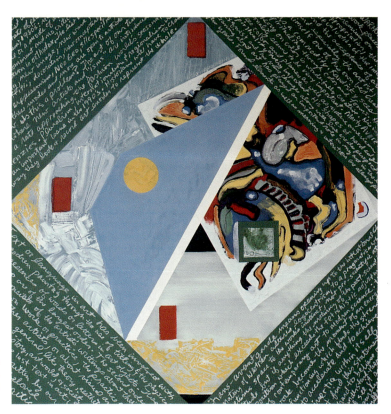

B. Atkinson
*Abstraction (from Education
Schemata Series)*
48" x 48" (121.9 cm x 121.9 cm)
Canvas

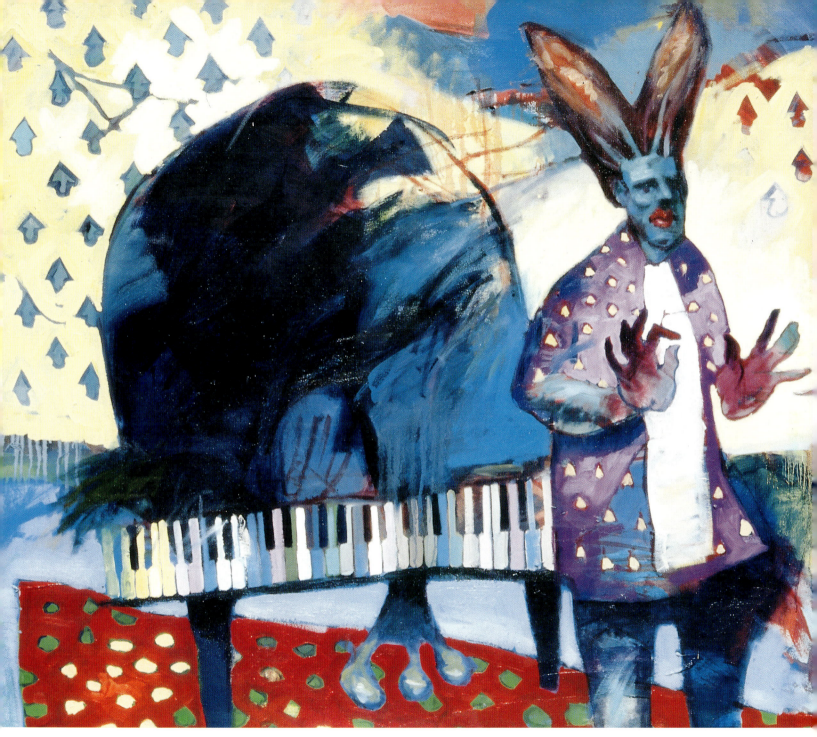

William Barnhart
The Piano Teacher
52" x 62" (132.1 cm x 157.5 cm)
Canvas

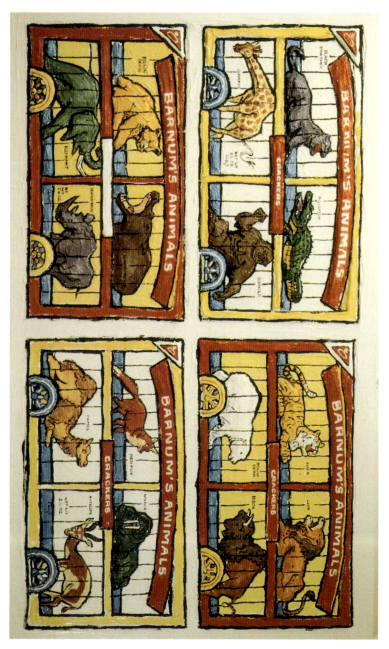

Leslie Lew Burns
Animal Crackers
50" x 30" (127 cm x 76.2 cm)
Canvas

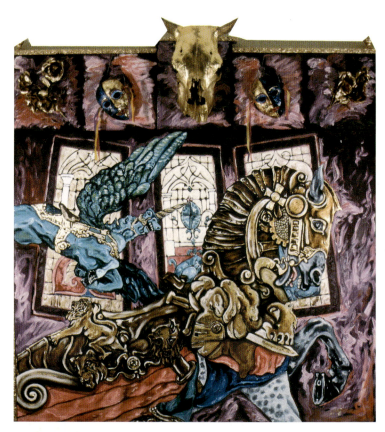

Frank G. Hoffman
ISM (Echoes on Empty Walls)
64" x 63" (162.6 cm x 160 cm)
Canvas duck

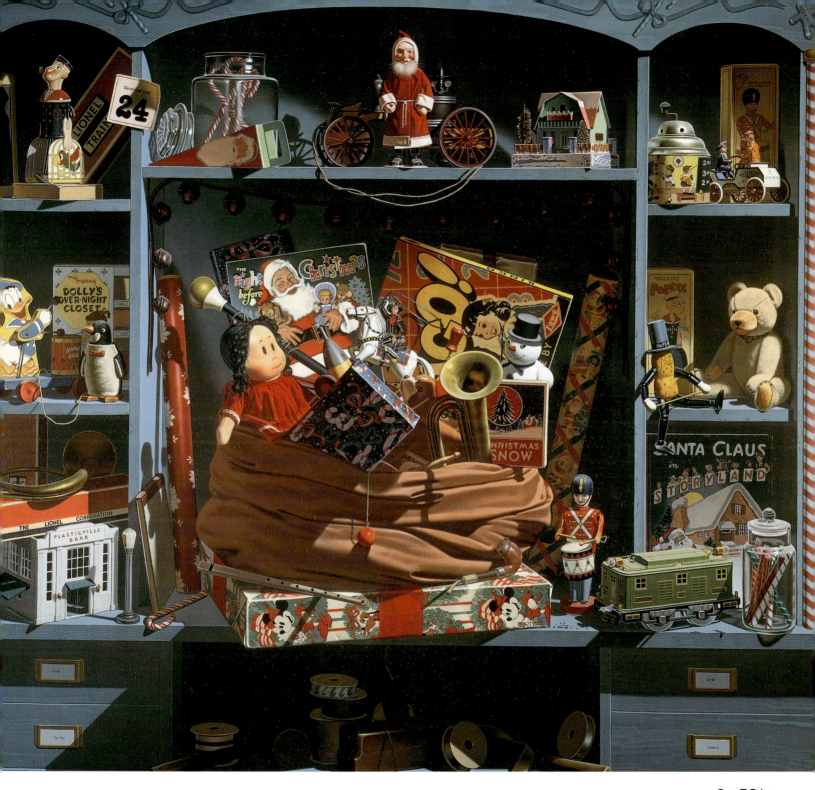

Gary T. Erbe
The Night Before Christmas
52" x 59" (132.1 cm x 149.9 cm)
Canvas

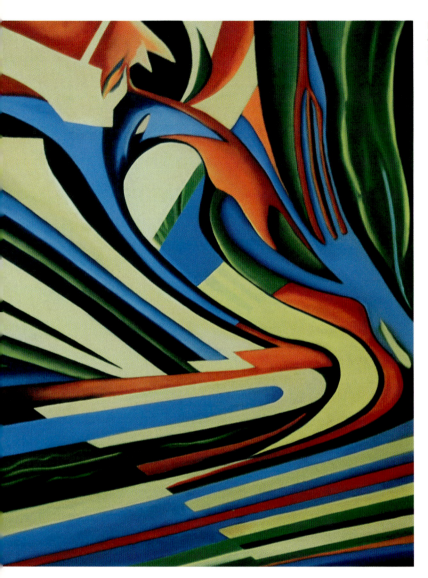

Patricia Brown
In the Beginning
36" x 30" (91.4 cm x 76.2 cm)
Linen canvas

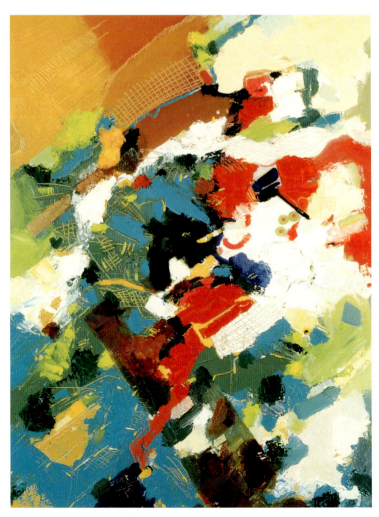

Atanas Karpeles
Crystal
48" x 36" (121.9 cm x 91.4 cm)
Linen canvas

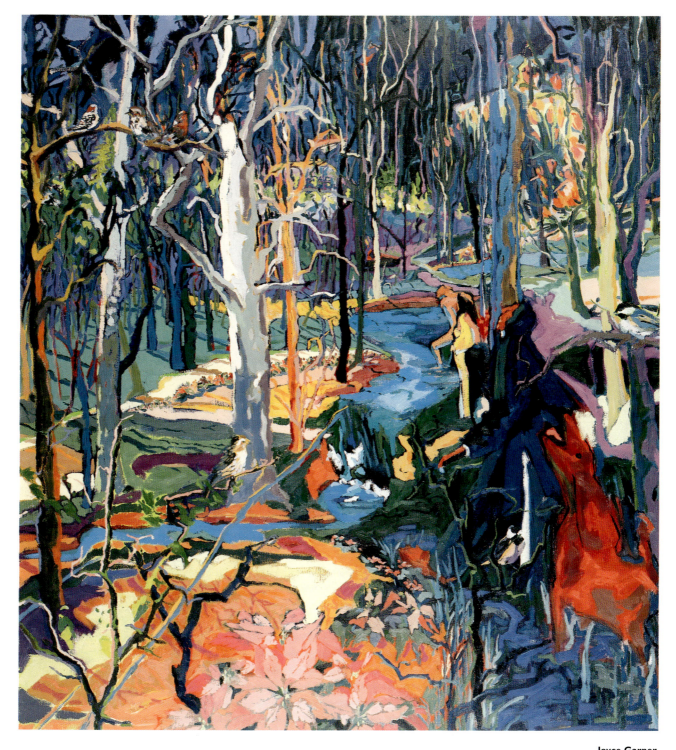

Joyce Garner
Source (Orpheus and Eurydice Series)
66" x 60" (167.6 cm x 152.4 cm)
Linen canvas

Patrick O'Kiersey
Blue Ridge
30" x 24" (76.2 cm x 61 cm)
Canvas

Esther Levy
Colors of the Duke No. 10
67" x 65" (170.2 cm x 165.1 cm)
Canvas

Lucille Dratler
Untitled
48" x 36" (121.9 cm x 91.4 cm)
Oil with wax
Canvas

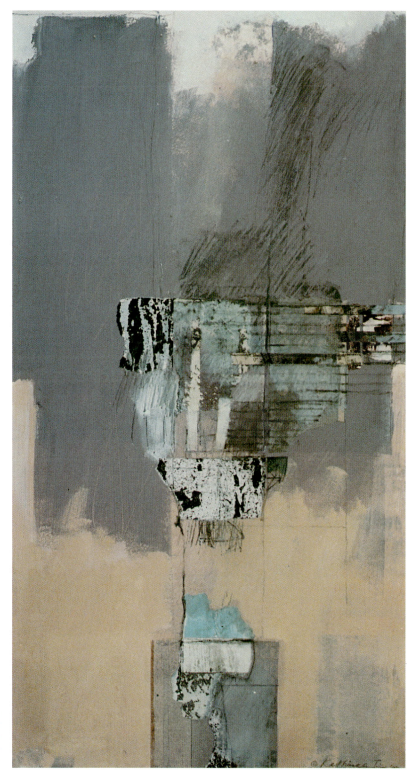

Katherine Chang Liu
I Knew a Flutist
23" x 12" (58.4 cm x 30.5 cm)
Oil with gesso
300 lb. Hot press paper

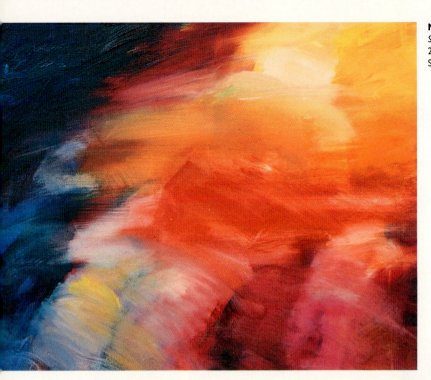

Maxine Warren
Shaman's Light Dance #4
24" x 30" (61 cm x 76.2 cm)
Stretched canvas

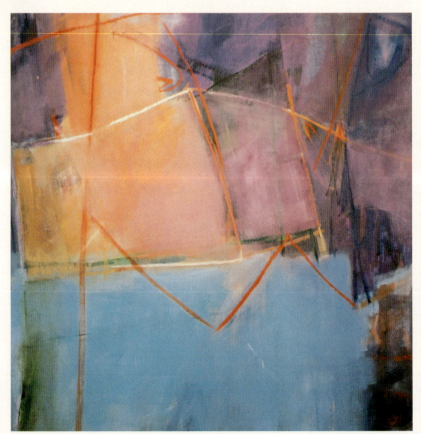

Esther Levy
Colors of the Duke No.1
67" x 66" (170.2 cm x 167.6 cm)
Canvas

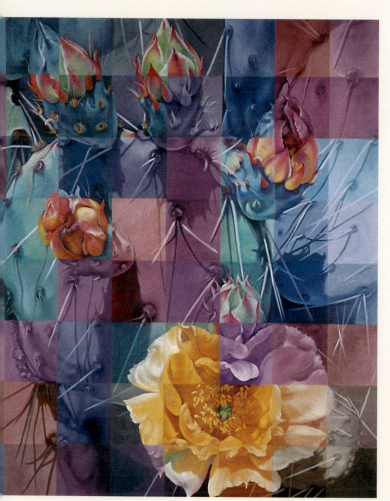

Brenda Semanick
Un Flor Amarillo
40" x 36" (101.6 cm x 91.4 cm)
Canvas

Lindé B. Martin
Sound of the Earth
47" x 59" (120 cm x 150 cm)
Linen

Ioan Chisu
Great Passage
20" x 24" (50.8 cm x 61 cm)
Dutch canvas

Robert Lamell
The Scent of Jasmine
30" x 24" (76.2 cm x 61 cm)
Canvas

Dennis Revitzky
Ancient Figure II
40" × 28" (101.6 cm x 71.1 cm)
Canvas

Taylor Spence
Wiggins Fork Crossing, 1992
36" x 48" (91.4 cm x 121.9 cm)
Canvas

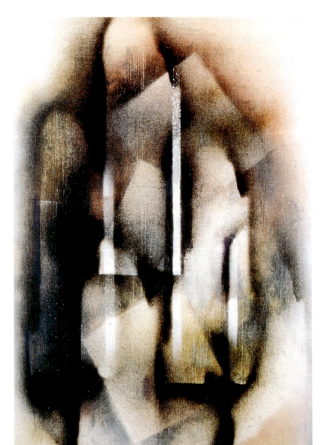

Nydia Preede
Of the Spirit
24" x 18" (61 cm x 45.7 cm)
Canvas

Winston Hough
Figure
24" x 19" (61 cm x 48.3 cm)
Oil with acrylic ground
Canvas

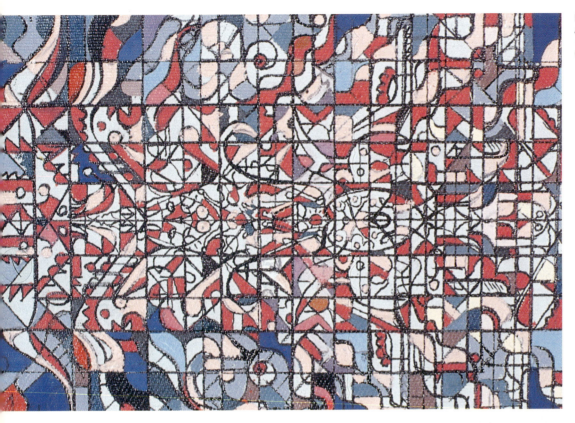

Ioan Chisu
Mad Forest
18" x 22" (430 cm x 46 cm)
Canvas

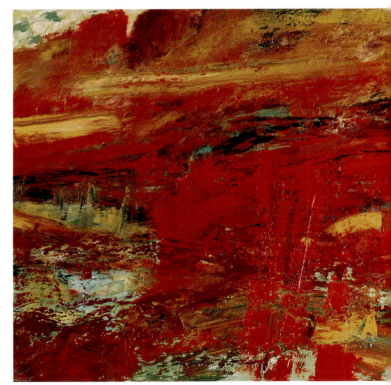

Patrick O'Kiersey
Colorado Red
60" x 72" (152.4 cm x 182.9 cm)
Canvas

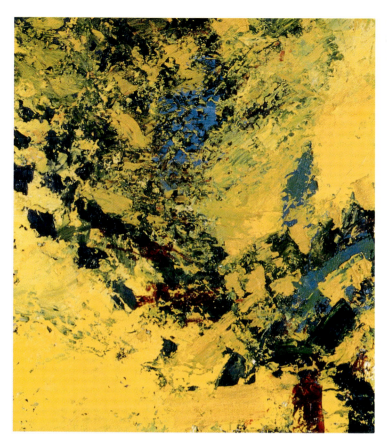

Patrick O'Kiersey
June Noon
36" x 32" (91.4 cm x 81.3 cm)
Canvas

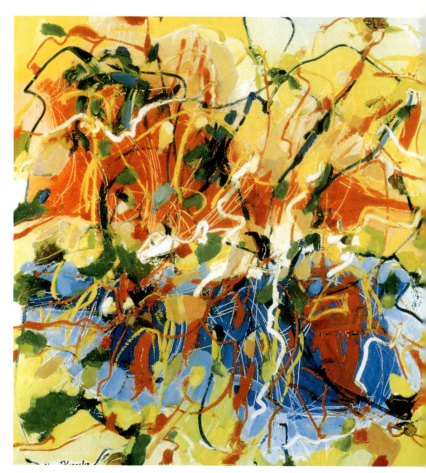

Atanas Karpeles
Below As Above
48" x 48" (121.9 cm x 121.9 cm)
Cotton canvas

133

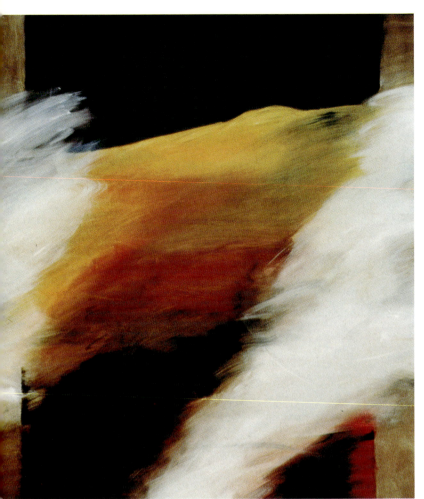

Maxine Warren
In My End Is My Beginning
(Private Words for T.S. Eliot Series)
48" x 44" (121.9 cm x 111.8 cm)
Canvas on stretchers

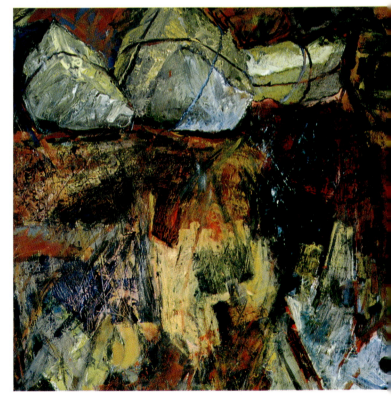

Gloria B. Blades
Stones Tied Together to
Keep the House Safe
39" x 45" (99.1 cm x 114.3 cm)
Canvas

Kathryn Frund
Fin-de-Siecle II (Triptych)
10" x 10" each panel
(25.4 cm x 25.4 cm each panel)
Oil with found objects and metal
Panel

<div align="right">

Kathryn Frund
Heaven & Earth (Diptych)
11" x 11" each panel
(27.9 cm x 27.9 cm each panel)
Canvas

</div>

Margaret Arthur
Magic
68" x 100" (172.7 cm x 254 cm)
Linen canvas

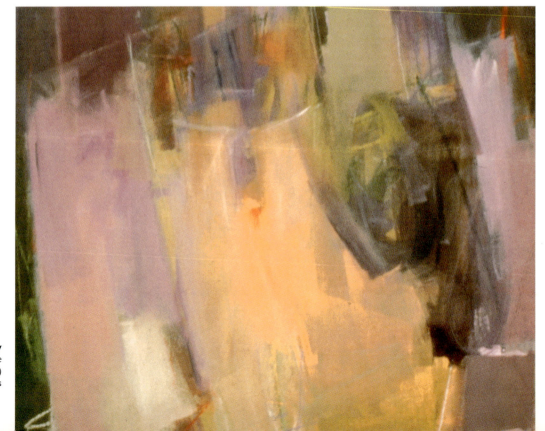

Esther Levy
Deep Purple
52" x 63" (132.1 cm x 160 cm)
Canvas

Jorge Bowenforbés
Los Pescadores-STABROEK
40" x 56"
(101.6 cm x 142.2 cm)
Gesso-primed canvas

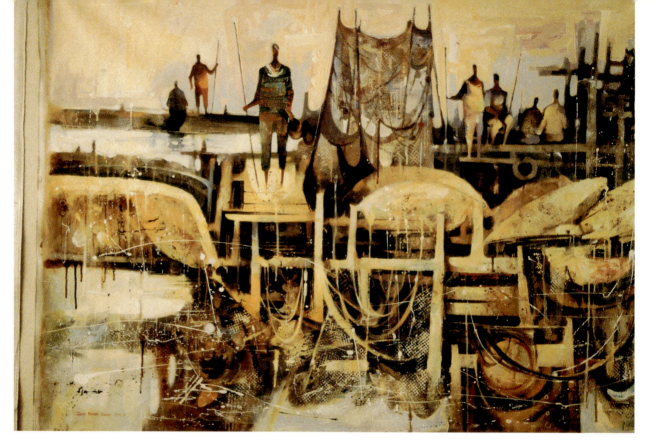

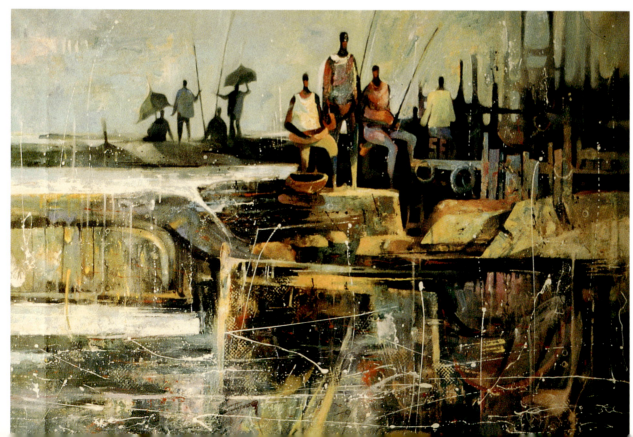

Jorge Bowenforbés
Los Pescadores-UITVLUGT
40" x 56" (101.6 cm x 142.2 cm)
Gesso-primed canvas

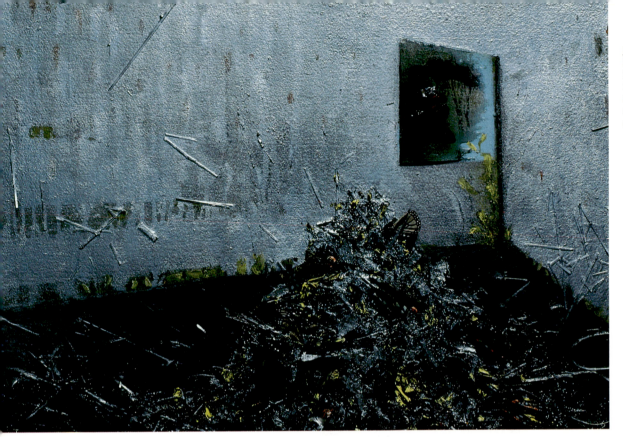

Janet L Culbertson
Butterfly Heap
22" x 30" (55.9 cm x 76.2 cm)
Oil with mixed media: butterflies
(found dead on beach), collage,
silver, and glass chips
Arches 400 lb. paper

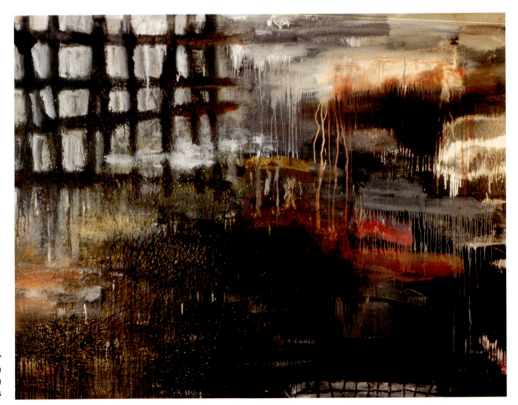

Margaret Arthur
The Raven
71" x 93" (180.3 cm x 236.2 cm)
Canvas

Ioana Datcu
Intersections of Fate
48" x 60" (121.9 cm x 152.4 cm)
Masonite

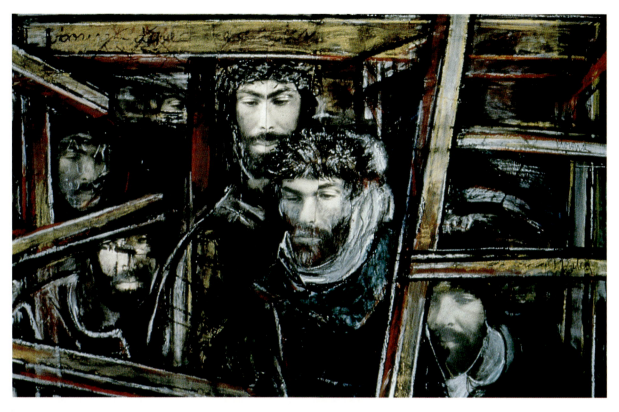

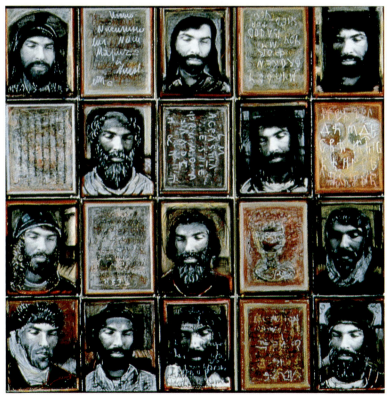

Ioana Datcu
Twelve for Supper
80" x 80" (203.2 cm x 203.2 cm)
Photo paper

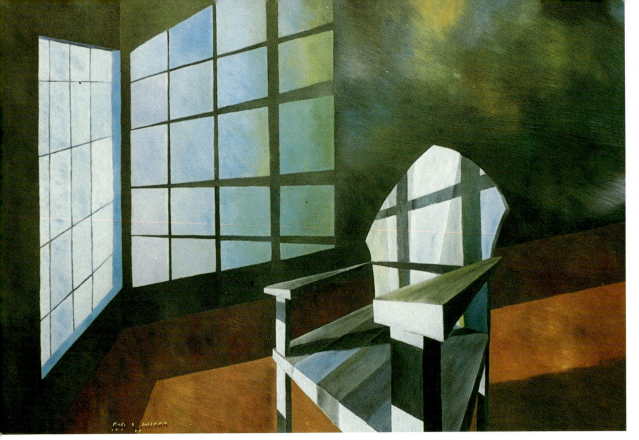

Ras Wollega
My Mind-Vast With No One Home
24" x 36" (61 cm x 91.4 cm)
Canvas

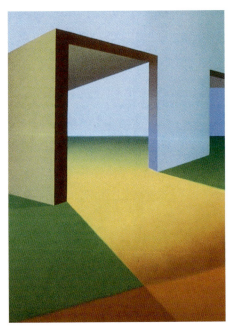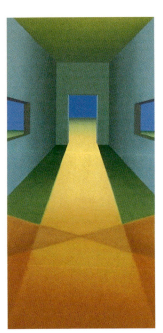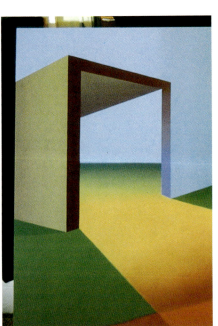

R. Schofield
Changes in Time
48" x 108" (121.9 cm x 274.3 cm)
Pressed board

About the Judges

Tom Nicholas, N.A., A.W.S., D.F., and his wife, Gloria, have maintained a gallery, home, and studio in Rockport, Massachusetts since 1962. Born in Middletown, Connecticut, he attended the School of Visual Arts and the Famous Artists School in Westport, Connecticut. In 1961 he was awarded a traveling scholarship from the Elizabeth T. Greenshield Grant. His work is represented in a dozen museum collections, including the Butler Institute of American Art in Ohio, the Farnsworth Museum in Maine, the Springfield Art Museum in Missouri, and the Peabody Museum in Massachusetts. Tom Nicholas's award-winning art work has been shown throughout the United States in more than thirty-five one-man shows.

John Charles Terelak was born in Boston, Massachusetts in 1942. He attended the Vesper George School of Art, also in Boston, where he later became an instructor. Mr. Terelak founded the Gloucester Academy of Fine Arts in Gloucester, Massachusetts, which he directed for many years. In addition to numerous one-man exhibitions (at Mongerson-Wonderlich Gallery in Chicago, Grand Central Art Galleries in New York, and locations throughout the United States) his work has been shown at the National Academy of Design, Boston's Museum of Fine Arts, the Springfield Museum, the Butler Museum, and is part of the Andrew Mellon Collection. Called both an American Traditionalist and an American Impressionist, John Terelak now works in Rockport, Massachusetts, where he resides with his wife and four children.

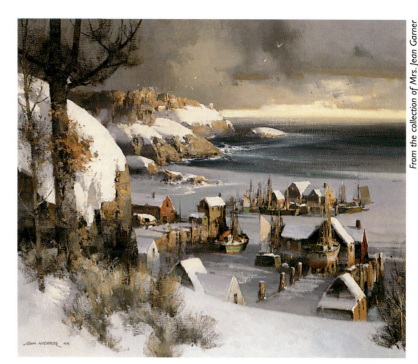

Tom Nicholas, N.A., A.W.S., D.F.
Along the Northeast Coast
30" x 40" (76.2 cm x 101.6 cm)
Canvas

John Charles Terelak
Gloucester Harbor, Winter
30" x 40" (76.2 cm x 101.6 cm)
Canvas

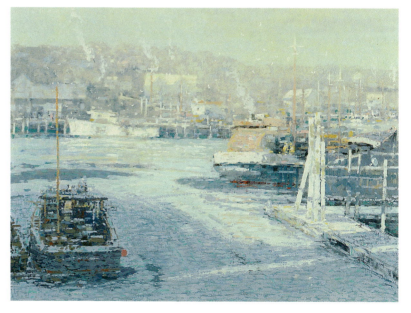

Index

Directory

Ann Stewart Anderson
600 East Saint Catherine
Louisville, KY 40203

Margaret Arthur
2575 Augustine Drive
Parma, OH 44134

Christine F. Atkins
154 Minimine Street
Stafford. Queensland 4053
AUSTRALIA

B. Atkinson
821 North Bellis Street
Stillwater, OK 74075

Armanda Balsamo
232 Lee Street #1F
Evanston, IL 60202

Ira A. Barkoff
186 Dibble Hill Road
West Cornwall, CT 06796

Jeffrey L. Barnhart
568 Philadelphia Avenue
Chambersburg, PA 17201

William Barnhart
541 North Macdonald
Mesa, AZ 85201

Georgiana Cray Bart
123 Brader Drive
Wilkes-Barre, PA 18705

Jann T. Bass
2700-B Walnut Street
Denver, CO 80205

Natalie Becker
97 Barchester Way
Westfield, NJ 07090

Scott Bennett
2715 Highway 138
Fairburn, GA 30213

Donald L. Berry
P. O. Box 116
331 West Main Street
Purcellville, VA 22131

Gloria B. Blades
11750 Rexmoor Drive
Richmond, VA 23236

Bogomir Bogdanovic
108 Park Lane
Warwick, NY 10990

Jorge Bowenforbés
P. O. Box 1821
Oakland, CA 94612

Loryn Brazier
1904 Hanover Avenue
Richmond, VA 23220

Walter Brightwell
946 Reef Lane
Vero Beach, FL 32963

Patricia Brown
815 Runningwood Circle
Mountain View, CA 94040

Gerri Brutschy
94 Portola Avenue
Daly City, CA 94015

Leslie Lew Burns
604 Douglas Road
Chappaqua, NY 10514

John Caggiano
76 South Road
Rockport, MA 01966

Joanna Calabro
74 Main Street
Rockport, MA 01966

Helen H. Carmichael
159 Jamaica Road
Tonawanda, NY 14150

Ioan Chisu
5027 North Harding 1W
Chicago, IL 60625

Reid Christman
165 23rd Avenue
Vero Beach, FL 32962

Roberta Carter Clark
47-B Cheshire Square
Little Silver, NJ 07739

Mary Close
129 East 82nd Street #7C
New York, NY 10028

Jack Coggins
P. O. Box 57
Boyertown, PA 19512

Frank P. Coras
44 Merrimac Street
Newburyport, MA 01980

Bernard Corey
101 Main Street
South Grafton, MA 01560

Janet L. Culbertson
P. O. Box 455
Sheller Island Heights, NY 11965

Ioana Datcu
2552 Bunker Lake Boulevard NE
Ham Lake, MN 55304

Leslie B. De Mille
50 Cathedral Lane
Sedona, AZ 86336

Tania Dibbs
P. O. Box 8106
Aspen, CO 81612

Sharon Di Giacinto
6741 West Cholla
Peoria, AZ 85345

Harvey Dinnerstein
933 President Street
Brooklyn, NY 11215

Kevin M. Donahue
2995 Hilltop Drive
Ann Arbor, MI 48103

Lucille Dratler
844 10th Street
Apartment C
Santa Monica, CA 90403

Elsie Eastman
345 6th Street
Brooklyn, NY 11215

Gary T. Erbe
539 42nd Street
Union City, NJ 07087

Tony Eubanks
1342 Ten Bar Trail
Southlake, TX 76092

Judith Futral Evans
34 Plaza Street
Apartment 808
Brooklyn, NY 11238

Henryk Fantazos
227 West Hill Avenue
Hillsborough, NC 27278

Tod W. Fassbender
2041 Rutledge Street
Madison, WI 53704

Sidney Findling
75 Montgomery Street 17A
New York, NY 10002

Mark Flickinger
825 North 3rd
Arkansas City, KS 67005

Katherine Frund
4 Glover Avenue
Newtown, CT 06470

Valori Fussell
P. O. Box 4354
Santa Barbara, CA 93140

Joyce Garner
7300 Happy Hollow Lane
Prospect, KY 40059

David Garrison
831 South Garfield
Burlington, IA 52601

Walter Garver
4230 Tonawanda Creek Road
East Amherst, NY 14051

Bob Gerbracht
1301 Blue Oak Court
Pinole, CA 94564

Wendy Gittler
780 West End Avenue
New York, NY 10025

Rolland Golden
78207 Woods Hole Lane
Folsom, LA 70437

Beatrice Goldfine
1424 Melrose Avenue
Elkins Park, PA 19027

Toby Goldman
237 East 20th Street
New York, NY 10003

Barbara Goodspeed
11 Holiday Point Road
Sherman, CT 06784

Keith Grace
3204 North View Road
Rockford, IL 61107

Michael Graves
10-5 Hayward Lane
Millbury, MA 01527

Albert Handell
P. O. Box 9070
Santa Fe, NM 87504-9070

Christine Hanlon
P. O. Box 9852
San Rafael, CA 94912

David Hardy
4220 Balfour Avenue
Oakland, CA 94610-1750

Mary Hargrave
6 Colonial Avenue
Sandmont, NY 10538

Kathryn S. Heuzey
121 Lawrence Hill Road
Cold Spring Harbor, NY 11724

Rene Hinds
733 Amsterdam 10C
New York, NY 10025

Frank G. Hoffman
16376 Germaine Court
Rosemont, MN 55068

Winston Hough
937 Echo Lane
Glenview, IL 60025

Bonnie Iris
4500 19th Street
Boulder, CO 80304-0615

Debra Reid Jenkins
1284 Lancaster NW
Grand Rapids, MI 49504

Gregory Johnson
965 Timberlake Trail
Cumming, GA 30131

Sandra A. Johnson
3550 Hawk Drive
Melbourne, FL 32935

Salomon Kadoche
1454 Orchard Road
Mountainside, NJ 07092

S. H. Kale
P. O. Box 1610
Black Canyon City, AZ 85324

Kathleen Kalinonwski
9120 Nestor NE
Comstock Park, MI 49321

Ivan N. Kamalic
8B Main Street
Rockport, MA 01966

Atanas Karpeles
1766 East Vistillas Road
Altadena, CA 91001

Martha Kellar
3 Robin Lane
La Luz, NM 88337

Eileen Kennedy-Dyne
26 Spring Street
Freehold, NJ 07728

Neal Korn
912 Pennsylvania Avenue
Union, NJ 07083

Kristi Krafft
4782 Encinal Cyn. Road
Malibu, CA 90265

Beti Kristof
P. O. Box 3999
Mammoth Lakes, CA 93546

Ann Kromer
40 Beechwood Lane
Ridgefield, CT 06877

Anne Van Blarcom Kurowski
16 First Street
Edison, NJ 08837

Robert Lamell
2640 Wilshire Boulevard
Oklahoma City, OK 73116

Ann Boyer LePere
6408 Gainsborough Drive
Raleigh, NC 27612

Esther Levy
15 Beacon Court
Annapolis, MD 21403

Katherine Chang Liu
1338 Heritage Place
Westlake Village, CA 91362

Lynne Lockhart
302 Bay Street
Berlin, MD 21811

Noma Lucas
2120 17th Avenue
Marion, IA 52302-2023

Gregory Lysun
481 Winding Road North
Ardsley, NY 10502-2701

Kerri McLaughlin
418 East 8th Street
Moscow, ID 83843

Fred MacNeill
23 Dana Road
Concord, MA 01742

Leslie Maggy-Taylor
5511 Northfork Court
Boulder, CO 80301-3548

Ward P. Mann
77 Rocky Neck Avenue
Gloucester, MA 01930

Agnes Manning
12 Ashbrook Drive
Hampton, NH 03842

Lindé B. Martin
244 Seaborg Place
Santa Cruz, CA 95060

Babette Martino
1435 Manor Lane
Blue Bell, PA 19422

Eva Martino
1435 Manor Lane
Blue Bell, PA 19422

Giovanni Martino
1435 Manor Lane
Blue Bell, PA 19422

Jeanette Martone
47 Summerfield Court
Deer Park, NY 11729

Dean Mitchell
11918 England
Overland Park, KS 66213

Luis Molina
42-10 82nd Street 6-0
Elmhurst, NY 11373

Stephen G. Mollison
18 Risley Street
Carina. Brisbane
Queensland. 4152
AUSTRALIA

Roy Morrisey
1837 East Campus Way
Hemet, CA 92544

Gloria Moses
2307 Bagley Avenue
Los Angeles, CA 90034

Christine Mosher
13 Main Street
Rockport, MA 01966

Donald Mosher
13 Main Street
Rockport, MA 01966

Murray Muldofsky
1216 Ocean Parkway
Brooklyn, NY 11215

Jeanette Murray
141 Wooster Street 5D
New York, NY 10012

Chip Myers
2902 Duncan Street
Cola, SC 29205

Thomas M. Nicholas
8 Rear Apple Street
Essex, MA 01929

Nathalie Nordstrand
384 Franklin Street
Reading, MA 01867

Desmond O'Hagan
2882 South Adams Street
Denver, CO 80210

Patrick O'Kiersey
3240 Telegraph Avenue
Oakland, CA 94609

George Oswalt
6713 Talbot Canyon Road
Oklahoma City, OK 73116

Anne Page
P. O. Box 159
Saratoga, NY 82331

Periklis Pagratis
411 New York Avenue NE
Washington, DC 20002

Lisa Palombo
226 Willow Avenue
Hoboken, NJ 07030

Jeff Pavone
50-04 103rd Street
Corona, NY 11368

Elissa Paystank
20 Knox Hill Road
Morristown, NJ 07960

Alexander C. Piccirillo
26 Vine Street
Nutley, NJ 07110-2636

Mary Poulos
16 Winona Trail
Lake Hopatcong, NJ 07849

Steve Powers
638 Prospect Street
Maplewood, NJ 07040

Nydia Preede
Box 344
Eatontown, NJ 07724

Carole C. Quam
19944 Upper Greatland Drive
Chugiak, AK 99567

Katherine Reaves
163 Exchange Street, #404
Pawtucket, RI 02860

Mitsuno Ishii Reedy
1701 Denison Drive
Norman, OK 73069

Dennis Revitsky
131 Monroe Street
Honeoye Falls, NY 14472

Susan Sarback
4217 Oak Knoll Drive
Carmichael, CA 95608

Nick Scalise
59 Susan Lane
Meriden, CT 06450

R. Schofield
P. O. Box 10561
Tampa, FL 33679

Brenda Semanick
3325 North Deerspring Court
Tucson, AZ 85750

Suzanne Shedosky
1120 Hahnaman Road
Rock Falls, IL 61071

Joseph Sheppard
c/o Saint Claire Association
1009 North Charles Street
Baltimore, MD 21201

Jo Sherwood
1401 Camino Cruz Blanca
Santa Fe, NM 87501

F. Sinsabaugh
P. O. Box 1215
Danville, IL 61832

Taylor Spence
984 Lincoln
Eugene, OK 97401

Lucille T. Stillman
8 Drum Hill Lane
Stamford, CT 06902

Urania Christy Tarbet
P. O. Box 1032
Diamond Springs, CA 95619

Bill Teitsworth
Rural Route 6, Box 6427
Moscow, PA 18444

John Terelak
12 Prospect Street
Rockport, MA 01966

Janis Theodore
274 Beacon Street
Boston, MA 02116

Patricia M. Tolle
10111 Marine View Drive
Mukilteo, WA 98275

Libby Tolley
2116 Inyo Drive
Los Osos, CA 93402

Bruce Backman Turner
Story Street
Rockport, MA 01966

David VanDenBerg
3325 North Deerspring Court
Tucson, AZ 85750

Emigdio Vasquez
555 North Cypress Street
Orange, CA 92667

Gretchen H. Warren
1895 Bluff Street
Apartment C
Boulder, CO 80304

Maxine Warren
Rural Route 2, Box 227
Ponca City, OK 74604

William Welch
P. O. Box 2847
Nantucket, MA 02584

D. Wels
1726 Second Avenue
New York, NY 10128

Wilma Wethington
2 Linden Drive
Wichita, KS 67206

Charlotte Wharton
594 Chandler Street
Worcester, MA 01602-1731

Jim Williams
6045 Daniel Street
Philadelphia, PA 19144

Joyce Williams
11246 Kiowa Place
Apple Valley, CA 92308

Ras Wollega
691 Rollins Road 9
Burlingame, CA 94010

David B. Young
1491 East Center Street
Springville, UT 84663

Shirley Cean Youngs
398 Fitchville Road
Bozrah, CT 06334

Zimos
5195 Caminito Chorro
San Diego, CA 92105

Frank E. Zuccarelli
61 Appleman Road
Somerset, NJ 08873